See What I Mean

See What I Mean

An Introduction to Visual Communication

John Morgan

Lecturer in Communication, East Devon College

and

Peter Welton

Dean of Arts, Crewe and Alsager College of Higher Education

Edward Arnold

A division of Hodder & Stoughton

LONDON NEW YORK MELBOURNE AUCKLAND

© 1986 John Morgan and Peter Welton

First published in Great Britain 1986
Reprinted 1987, 1988, 1989

Distributed in the USA by Routledge, Chapman and Hall, Inc.
29 West 35th Street, New York, NY 10001

British Library Cataloguing in Publication Data

Morgan, John
 See what I mean: an introduction to
 visual communication
 1. Visual communication
 I. Title II. Welton, Peter
 001.55′3 P93.5

 ISBN 0–7131–6466–2

Typeset in 10/12 pt Century Schoolbook Compugraphic
by Colset Private Ltd, Singapore.
Printed and bound in Great Britain for Edward Arnold, the
educational, academic and medical publishing division of Hodder
and Stoughton Limited, 41 Bedford Square, London WC1B 3DQ
by The Bath Press, Avon.

Contents

Acknowledgements

The authors and publishers wish to thank the following for permission to use copyright material:

Harper & Row for Schramm's model (p. 8) from W. Schramm: *Men, Messages and Media* (1973); Holt, Rinehart & Winston for Berlo's model (p. 10) from D.K. Berlo: *The Process of Communication* (1960); the *Journal of Experimental Psychology* for the illustrations on p. 58 from L. Carmichael, H.P. Hogan and A.A. Walker: 'An experimental study of the effect of language on the reproduction of visually perceived forms' (1932) vol. 15, pp. 76–86; the MIT Press for Jakobson's model (p. 108) from 'Linguistics and poetics' in T.A. Sebeok, ed., *Style and Language* (1960); the University of Illinois Press for the Osgood and Schramm model (p. 24) from W. Schramm, ed., *The Process and Effects of Mass Communication* (1954) and for the Shannon and Weaver model (p. 5) from C.E. Schramm and W. Weaver: *The Mathematical Theory of Communication* (1949); the Centre for Educational Technology/Overseas Visual Aids Centre for the drawing on p. 69 from Alan C. Holmes: *A Study of Understanding of Visual Symbols in Kenya* (1963).

The Bill Brandt photo from *Picture Post*, 1939, on p. 40 is reproduced by permission of Noya Brandt – The Estate of Bill Brandt. Calor Gas Limited have kindly permitted us to use their advertisement and the truncated version of it on p. 55 and 56. The Mint Cool advertisement on p. 92 appears by courtesy of Ashe Labs; the logo on p. 85 by courtesy of the Exeter and Devon Arts Centre. We would also like to thank Portland Cement for allowing us to use photos of their tanker by Peter Welton. The photo of Wells Cathedral is by George Hall; the photo of the mosque on p. 95 is courtesy of the Iraqi Cultural Institute; the 'storm' sequence photos and those of the two boys are by Steve Hewitt. Peter Welton provided the 'stop smoking' sign and did the artwork for pages 8, 22, 31, 42, 43, 44, 59, 60, 61 and 63.

Acknowledgements for the other reproductions appear in the captions.

For Ann Morgan and Liza Welton
without whom this book would never have been written

Introduction

Understanding why pictures and designs affect us is a difficult task. Many answers have been offered, but usually in a form which is inaccessible to the non-specialist. The relevant studies are classified as psychology, philosophy, history, linguistics, sociology, aesthetics, information theory and even literary criticism. This book attempts to present a number of the most important areas of research in a form which is both clear and practical; the authors have learnt from their students to be constantly aware of the question 'So what?'

Many of the issues which we raise are complex, and students need to understand the main lines of the argument before tackling the original writers whom we mention. We hope we have been able to simplify without doing violence to the originals; in any case, we would only regard ourselves as having been successful in our task if the reader is impelled to move on from the basis which we offer to detailed study of those areas which prove to be of particular interest.

Textbooks on communication usually concentrate on one or other of the approaches we have mentioned, and most start by looking at language or at the psychology of face-to-face encounters. For those beginning to study communication or the mass media, the visual image is a more useful starting-point, forcing the student to be aware of the often secondary place of the element to which previous education is likely to have given paramount importance: the word.

For the general reader, we hope to show some of the richness of means by which the eye can be pleased and persuaded. In particular, we are interested in the ways through which consideration of the traditions of other cultures can help us to be more aware of routines and conventions which our own society takes for granted.

The usefulness of communication theory to students of art and design has in the past been restricted by two factors: a proper suspicion of verbalization as a possible distraction from visual expression, and the narrow range of theory which was available. The formula sender – encoder – channel – decoder – receiver was considered adequate, and quite useful for the narrow requirements of a design brief; that there was more to communication than this, and that much of it was of equal importance to the fine artist, was a notion which too often went by default. We hope that this book will help to foster discussion by visual communicators of the relationship between the theories we describe.

In the humanities as in the social sciences, there is often a difficulty over labels for concepts. The same word may be used in different senses by two writers in the same field, or a single

concept may be identified by several different terms. This is also true of researchers in the field of communication, who have latched onto convenient words from everyday speech or from foreign cultures and endowed them with precise, narrow definitions which suit their purposes – words such as sign, symbol, icon and code. To have attempted a comprehensive guide to these usages would have made complicated a book which is intended as a simple introduction. We have, accordingly, taken the commonest label for a concept except where this would have caused confusion.

1 The Process of Communication

Expression and communication

You get up in the morning, go over to your wardrobe, and wonder what to wear. Is it a jeans-and-tee-shirt day, a sober-suit day, or a leather-jacket-and-boots day? If you have such a range of clothes, your selection will depend upon two things: the way you feel and the version of yourself that you wish to send out to other people. The suit is a sign of conformity to the organization which employs you. Choosing a tee shirt and jeans may tell other people that you are adopting an informal role: 'I'm not on duty – it's the weekend.' For you, it may also be a part of the pleasure of being away from work: 'Hurray! Thank goodness I can relax today.' By contrast the leather jacket and boots for some people may be a way of announcing: 'I'm tough and energetic; watch me go!' and may also serve to build up their self-confidence to face a social encounter in which they feel a need to compete.

Every time we communicate, these two different forces are in operation: on the one hand, the need to influence the other person, and on the other, the need to remind ourselves who we are or who we want to be. The relative strength of the impulses will vary from minute to minute, and there are many occasions when we simply wish to express ourselves for the inherent pleasure of the act; I may, for instance, spend a morning cleaning my motor-bike for the sheer pleasure I know I will get from polishing the chrome parts and achieving a real mirror finish in the paintwork. It may well be that in doing this simple but satisfying job I will have time to think about other problems I have and I may be able to come to terms with conflicting emotions. I could use this task as a kind of therapy. The chances are, however, that in the back of my mind is the awareness that I am likely to meet some friends who will inevitably comment on the state of the bike and possibly draw conclusions about my attitude to this valued possession.

This book will concentrate on acts where the need to influence is paramount; not because we underrate the subjective importance of the visual arts as expression, but because we are concerned that both practitioners and consumers of the visual arts should be able to use them to the best effect.

The most intensely personal and expressive piece of work will produce an effect on a few of the people who see it, either because of their understanding of the circumstances which produced it or because of their broad experience and sensitivity. But if you are aiming at a wider audience than these few perceptive individuals, an awareness of the mechanics and psychology of the communication process can help to sharpen your presentation. The choice of a target remains in your hands – or in those of the client who is employing you.

Critical skills and visual communication

Professionals in any field need a vocabulary and a set of systems for analysing their work. This is as true in the visual field as in any other. The art-director in an advertising agency needs to be able to explain what is required to the photographer, the account director and the copywriter who form part of the team working on an advertising campaign. Each of them will discuss a particular proposal and go away with a precise idea of what has been agreed and how their tasks complement each other. Their discussions will have covered not only obvious questions such as the subject of the advertisement, camera angles and possible layout, but also more abstract questions of style, approach and potential audience. A measure of the effectiveness of the team is the precision with which each member can communicate the concepts required.

A wide range of occupations depends, as advertisers do, upon the visual skills of other people, occupations as diverse as railway guard, football coach, architect, or stage designer, all of whom rely for their success on conveying information to selected target groups in order that a desired response should be produced. As target groups or consumers of visual information become more skilled in receiving, understanding and reacting to such information, so the quality or effectiveness of the communication is improved and the subtlety of the messages can be developed. More than that, however, it is also possible that as we expand the visual awareness of consumers, they become more sophisticated in their awareness of the techniques deployed against them, which in turn provides a defence against unwanted blandishments from skilled communicators. The development of visual skills also opens up a range of pleasurable experiences which are denied to those who perceive visual media in simple, narrow terms.

Lasswell (1948) claimed that an act of communication was adequately explained only when every aspect of his famous question had been answered:

who	says what	in which channel	to whom	with what effect?

As a starting-point for the analysis of a communication, this cannot be bettered, although as we shall see the discussion can go very much further. For example, the message 'Come up and see me some time' means something very different when spoken by Mae West than it would in the mouth of Ronald Reagan; even from her, it has a different significance when she speaks it at a party than when she writes it in a letter; when addressed to a woman it clearly means something different from when a man is on the receiving end. And, of course, without a description of the effect which it produces, the story is incomplete.

Learning to communicate

The processes by which children learn to speak and, much later, to write are well documented; those by which we learn to make and decipher visual messages are just as complex but much less well studied. Our society places a high value on the word, both written and spoken, but new technology has helped to emphasize the importance of other means of communication: film and television depend primarily on picture rather than sound, and modern printing technology extends the range of colours, textures and shapes available to the advertiser and book designer. International trade puts a premium on any method of communication which can reduce dependence on expensive and sometimes confusing translations of the written word. We need greater awareness of the means by which we understand what we see, not simply because any study of humanity is fascinating, but because without it we shall be unable to take advantage of the technical, commercial and social possibilities of the latter years of the twentieth century. Others may take control of the channels and seek to manipulate us; only by understanding the techniques at their disposal will we be placed to defend our own interests.

Visual education today is too often an erratic and spasmodic affair of which the greater part takes place outside the classroom. The art class is an embattled tower of self-expression in a school which has been occupied by armies of facts. In defending this role, art teachers have had little time or energy to impart the analytic tools which would enable their students to discuss pictures, advertisements or exhibitions with the same precision that, say, an English teacher would give to the techniques displayed in a written text.

Children watch advertisements on television, read comics and magazines, discuss each other's clothes, play electronic games, observe road signs, browse through record sleeves, collect badges. Each of these activities has effects on the images they produce. The thoughtful art teacher will, if sufficient time can be squeezed in, use these images as the starting point for discussion of the processes which generated them and the effects they produce in others. These discussions will need to be supported by a clear awareness on the part of the teacher of the theories on which they depend, not in order to turn the lesson into another marshalling of 'facts', but because any teacher needs to have both an analytic and an intuitive understanding of the skills and perceptions which are being developed. If the students, too, acquire an analytical understanding of what they are doing, then this is a bonus.

In schools, there is a case for replacing the traditional expressive function of art education with one in which the 'language' of the visual world is taught. Such elements as colour, line, tone, shape, and so on are the building-blocks of visual communication yet, with some notable exceptions, most people leave school with only the haziest notion of them, to say nothing of the more abstract concepts which will be developed in this book. Yet the constant bombardment of visual images from many quarters is already shaping their lives, influencing their attitudes, tuning their responses. A well developed critical capacity applicable to the visual world should be the normal equipment of every school leaver, in the same way as an English teacher aims to form adults who are critics as well as receivers of the spoken and written word. This approach need not stifle the expressive needs of children but would better equip them positively to realize their purposes.

The first requirement of any field of study is to establish an overall framework within which discussion can take place. We need to consider a number of *models* of the communication process: each of these representations can only be a partial description, but each throws light on a particular aspect of the complexities of human interaction, and can help us to produce more effective messages.

The 'bull's-eye' model of communication

The simplest way of regarding communication is to see the sender of a message as an archer and the recipient as the bull's-eye in the

A *model* of a process is a simplified description in diagrammatic form. Models may be used as a way of summarizing and explaining the relationship between the influences on a given situation, or as a means of predicting the outcomes of a given situation.

middle of the target. The sender chooses a message, calculates the best way to send it and fires it off at the intended audience.

Take a simple situation: I wish to stop you smoking in my room. I have several choices to produce this effect; I could simply say to you, 'Would you mind very much not smoking in here?' or I could point out a notice which I have drawn and which lies on the table between us.

If for some reason I reject both of these, I can break into loud coughs and rush to open the window.

It is immediately apparent that in considering sender and receiver as archer and target, we have seriously oversimplified the nature of the transaction: the message has not only to be sent, it has to be understood and accepted, and each of the messages I have described could fail on this account. You may fail to recognize my pantomime as a message at all; you may be unfamiliar with the dialect which I speak; you may be unaware of the convention which produced the 'No Smoking' sign. There may be some distraction or interruption which prevents you from noticing my message: an attractive stranger may walk into the room, my table may be cluttered with other objects or a noisy lorry may pass the window. Finally, my choice of a way to convey my feelings may irritate, amuse or embarrass you.

This situation presents each of the elements in one of the earliest and most influential models of human communication, elaborated by Shannon and Weaver (1949) as an aid to improving the efficiency of telecommunications systems:

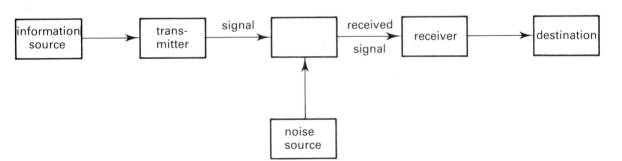

The most useful wider application of this model is to clarify potential causes of communication breakdown: each of the elements can contribute to misunderstanding and even conflict:

(a) *Noise:* any event which shares the same channel as a message and interferes with the receiver's ability to perceive it. In the example above, the attractive stranger, the other objects on the table and the passing lorry are all, in this sense, *noise*. A boldly coloured poster next to your delicate pastel may be noise; a nauseating scene of horror preceding your television advertisement can also be noise.

(b) *Information source:* The actual message may be confused in the mind of the sender: do I really wish to stop you smoking, or do I simply wish to exercise my authority? If I am unsure which is my real message, I may fail to transmit either.

(c) *Transmitter:* A message is said to be encoded when a conscious decision has been made by the sender to attempt to put the message across in a particular way and when the appropriate signs have been chosen – words, gestures, shapes, images. Of course, the signs chosen may fail to convey a message to you at all, or only a message which is so garbled that you completely misunderstand my intentions.

(d) *Channel:* The channel is the physical means by which the message is sent – the soundwaves or electromagnetic impulses which pass between sender and receiver. Related to this is the term *medium*, a broader term which includes all the types of equipment which extend the range of our communication: posters, radio and magnetic tape are all media. Each medium has its own peculiarities, advantages and disadvantages: the attributes of photography are quite distinct from those of pen and ink drawing, yet each is ideal for certain purposes.

(e) *Receiver:* We talk of decoding a message when the signs received are turned into meanings: if the communication has been successful, the meaning produced is close to that which the sender encoded. This does not, of course, always happen. The message may use unfamiliar signs and conventions: the 'No Smoking' sign may mean little to a person unfamiliar with the road signs which it resembles. Each group within a society has its own dialect, its own distinct variation on a more general language, and this is as true of visual as it is of verbal communication.

(f) *Destination:* The person or group at whom the sender has directed the message. The receiver may have no concepts equivalent to those included in the sender's message, although the words may appear to have been in some way decoded. The inhabitant of an oasis may have some trouble with the feelings implicit in the words 'sleet' and 'slush' when used by a Scottish Highlander. Furthermore, although the individual concepts may be shared by both parties, the complexity with which they are organized may be beyond the receiver's grasp.

We have so far discussed this model as a description of two people communicating face to face. It is even more useful when applied to more remote methods of communication: 'transmitter' could be interpreted as a telephone mouthpiece or as a modem (the

electronic device which connects a computer to a telephone line), in which case the channel becomes the telephone cable and the receiver, a telephone earpiece or another modem.

The model can also be used to describe the relationship between a number of organizations working on the same message – say, a television advertisement. An advertising agency, as information source, devises an advertising campaign and hires a film unit (transmitter) to produce an advertisement which is broadcast by a satellite television company (channel) to a cable company (receiver) which passes the transmission to the home (destination).

Communication as a skill

The last section began by describing communication as like an archer taking aim at a target: if the arrow hits the bull's-eye, it is because of the skill of the archer. A little consideration of the more detailed description, however, makes clear that the process is in fact interactive: both sender and receiver have a part to play in a successful transaction.

Both parties to a transaction must be active: as the sender struggles to find a way of encoding the message, the receiver must focus attention on it, interpret it, and if necessary seek clarification. Both parties are exercising knowledge, experience and skill. Successful communication depends on this, so that failure can rarely be blamed unhesitatingly on just one party.

Who is to blame if I fail to show you that, although I wish you to stop smoking, I do not wish you to interpret this as a simple assertion of my authority over you? It may be my fault for failing to give sufficient thought to the complexity of the problem. It may be your fault for failing to study my message attentively. Our relationship may make such delicacy impossible: our previous rivalries and mistrust may prevent this kind of message from being offered or accepted at face value – we see and hear what we expect, rather than what takes place. Both of us can improve our effectiveness with greater experience, discussion and practice: this is what is meant when communication is described as a skill.

A notice goes up to announce an important meeting of those involved in organizing and using the services of a creche. Only half of those expected actually come to the meeting. What can have gone wrong?

The poster may have failed to include vital information, like the time and place of the meeting. Because it used the same format as routine announcements, it may have failed to distinguish this meeting as important. The paper on which it was printed my have been of a colour normally used only by a small, specialized department. It may have been indistinguishable from a mass of other notices around it on the notice-board, so that the members of

the group failed to pick it out in their routine scanning of the notice-board as they came to work.

Every one of these failures can be described as ultimately a failure of skill, and therefore as something which can be remedied. Once the problem has been analysed, we can set about improving our chances of success next time. We need to look at the message, the interpretation and the receiver so that we can identify at which point confusion crept in.

Communication as shared experience

Communication does not involve the transmission of thoughts. This statement may seem perverse, but it is more than a quibble to say that what we exchange are messages, not thoughts. In listening to me, or in looking at the picture which I have drawn, you may have the illusion of being in direct touch with what is going on in my head. This is not so. You are trying to decode my message in order to infer the state of mind which produced it. In showing you my drawing, I am trying to produce in you a particular effect, which may or may not be the same as my state of mind in making the drawing.

My aim in communicating is always to do something – to make you like me, to stop you smoking, to get you to come to a meeting, to park your car here or to buy my house. Without such an aim, communication becomes purely expression. With such an aim, both parties must start from what they share: language, experience, knowledge and values.

Someone once remarked that, even if a miracle enabled us to talk to an ant, communication would be impossible because there would be nothing to talk about. The world of the ant is so totally dissimilar from our world that every word we exchanged would evoke a totally different range of experience in the two minds. In human discourse, this problem is reflected by the use of such expressions as 'They were speaking different languages' to describe people whose ideas are so far apart that communication between them seems all but impossible.

Wilbur Schramm (1973) devised a model of communication which expressed this restriction in graphic terms:

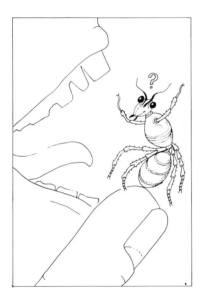

Fig. 1.1 Even if we were able to talk to an ant, we would have nothing to talk about.

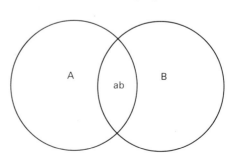

Fig. 1.2 Schramm's model of communication.

'The area ab where A's life-space overlaps that of B is the setting for their communication'.

In other words, we have to identify those parts of our experience which we share with our audience, and use this common pool of experience and ideas to provide equivalents for any novel ideas from beyond these limits. For example, I keep bees, but you are allergic to bee-stings and avoid the slightest contact with them. I want you to understand the pleasure which I take in going to my hives and in handling and caring for the bees. How can I do this? One solution might be to build upon our shared pleasure in gardening and in driving fast cars. Thus, handling bees without getting stung is something you might understand in terms of your pleasure in driving fast but safely; watching the development of a colony and keeping it in good condition to encourage a heavy honey crop can be felt as similar to your enjoyment of cultivating, watching plants grow and harvesting crops of vegetables or flowers.

In this example, the idea of the bee produces a different effect in both of us, this difference being the result of differences in our mental worlds. The study of communication is beset by examples of failure produced by such ambiguity. A camel means daily transport to a bedouin of the desert, an embarrassing sign of technological backwardness to the sophisticated Arab townsman, and an exciting novelty to the London child who rode a camel on a visit to the zoo last summer. Each person will interpret a picture of a camel in terms of their own experience, and may incorrectly assume that the picture means the same to others. We are easily misled into thinking that our shared use of a language implies a shared pool of experience.

A model of communication skill

Starting from Shannon and Weaver's model, Berlo (1972) developed a framework which demonstrates the complex web of skills and knowledge which two parties need if they are to communicate successfully: a more analytical version of the 'overlapping life space' which Schramm said was the setting for their communication. This model is a graphic representation of the factors which distinguish awkward, embarrassing or laborious transactions from those which give us pleasure and permit the apparently effortless cooperation on which so much of our daily life depends.

This is a summary: in its layout, it implies a number of definitions and explanations.

(a) Sender and receiver have to share the same set of *skills:* they have to use the same language or code, and they have to use

Fig. 1.3 Berlo's SMCR model of communication.

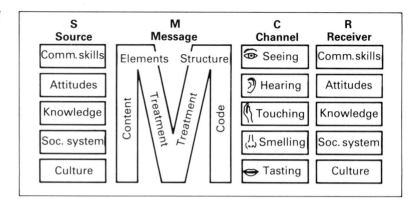

words or signs in the same way. For this to happen, they must have experience of the same *social system* and *culture* (the values, rules and beliefs through which people live).

Furthermore, they must share at least some *attitudes* to the subject of their conversation. Absolute disagreement on all aspects of the topic means that discussion is impossible: even an argument has to grow out of a fundamental level of agreement on some issues.

(b) The two parties must be linked by a *channel* or medium of communication.

(c) The message consists of a number of inseparable components which may be discussed individually but which work together to produce their effects. Their interdependence is implied by Berlo's 'M' framework which binds them together.
 (i) *Content:* the information or emotion which is the subject of the message.
 (ii) *Elements:* the individual items (words, sounds, brush-strokes, gestures, colours, pictures) which are assembled to form the message.
 (iii) *Structure:* the way in which the elements of the message are assembled. The same elements can produce different messages when combined in a different way: 'Dog bites man' is not the same as 'Man bites dog', and Chagall's lovers floating at the top of the painting would convey a different message if they lay along the bottom edge of the picture.
 (iv) *Treatment:* elements and structure may be combined in the same essential way, but a skilled communicator can introduce subtle variations to vary the impact of the final message: like the word 'style', this concept depends on the subjective contribution of the individual communicator.
 (v) *Code:* the rules and conventions on which the message is built, such as the alphabet used for writing, the grammar

of a language, or the 'Highway Code' used to establish the meaning of a road-sign.

Summary

An act of communication is one which aims to produce an effect in another person. If this intention is absent, we refer to the act as expression rather than communication. It is possible to improve the effectiveness of visual communicators by analysing the means which they use and by extending their range of concepts and the vocabulary which they use to discuss or explain their work. In so doing, they may deepen the quality of their response to visual media and be more sensitive to techniques which may be marshalled against them. The transmission of a message can be analysed into five components: selecting an idea to be conveyed, encoding it, transmitting it through a channel, decoding and interpretation by the receiver. Problems may occur at any one of these stages; in particular, noise may operate on the channel to prevent accurate transmission of the message itself. Communication depends upon a range of shared experiences, attitudes and knowledge.

Where do we go from here?

A most thorough view of communication theory is provided by C.D. Mortensen's *Communication: the study of human interaction* (McGraw-Hill, 1972); it is, however, demanding and expensive. D.K. Berlo's *The Process of Communication* (Holt, Rinehart & Winston, 1960) is more accessible and gives a broad introduction to the philosophy of communication. D. MacQuail and S. Windahl's *Communication Models* for the study of mass communications (Longman, 1982) concentrates on mass media models but is clear and concise. Slightly more demanding, but nevertheless quite accessible, is John Fiske's *Introduction to Communication Studies* (Methuen, 1982).

A useful exercise to sharpen one's critical vocabulary is to choose an artist, photographer or designer with whose work one is familiar and express in words what makes that work distinctive. A successful definition would permit someone who had never before encountered this work to identify samples of it in a folder of similar pictures. The similarity may be one of theme, subject, technique or historical context; indeed, as you gain confidence in this analysis, you may wish to increase the number of areas of similarity in order to sharpen the precision of your distinctions.

Many people are disturbed by the implications of such analysis,

feeling that it in some sense inhibits or distorts imagination and creativity. What are the potential advantages of an analytical approach to the communication process?

Any model or statement concerning communication must of necessity simplify the complex process which it describes. In describing your own field of study, what modifications would you wish to make to the models discussed in this chapter?

Berlo's model (p. 9) presents a number of features which source and receiver must share for successful communication to be possible: communication skills, attitudes, knowledge, social system and culture. Test this with the work of a skilled communicator (photographer, designer, painter, film-maker) which you know well. Is it possible to understand the work without all of these elements? Are there any additional elements which need to be added?

2 Noise and Feedback

Successful communication requires much more than finding words or signs which will express your meaning. You must be sure that the message produces in the receiver the effect which you intended; the degree to which you achieve this is one measure of your skill. No outside influence should be allowed to prevent the message from arriving intact and undistorted: if such intrusion is likely, some means must be found to compensate for its effects. Allowance should be made for possible distractions of the receiver. The actual effects produced by the message should be assessed; they may be markedly different from those intended.

Noise: physical and semantic

In the opening minutes of an educational radio programme on local history, the narrator described how a suspected witch was tied to a post still visible on the beach, and then left to drown as the tide came in. Not surprisingly, the remaining 25 minutes of the broadcast left almost no impression on the children listening, who were still absorbed in the horrific image of the drowning woman.

Noise is a distraction which disturbs the transmission of a message by intervening in the channel itself. During a radio broadcast, a defective motor in the vicinity of the receiver can produce interference, which is a form of *physical noise*. The story of the witch, on the other hand, was an aspect of the message itself which came to prevent the recipients from absorbing the message of the programme as a whole: we can refer to this as *semantic noise*.

Any striking or unusual aspect of a design can function as noise if it fails to reinforce the sender's intention: the gimmick which you use to attract the attention of the passer-by may be all that is noticed, and come to be thought of as the message itself. Noise may also be the effect of an aspect of the situation which the sender

Noise: anything which affects a signal, during its transmission from sender to receiver, so that the received signal is different from the one transmitted. It is usually random and unpredictable.

13

took for granted and included almost accidentally. At the crisis point during negotiations to settle an important industrial dispute, a representative of the employers was called straight from a banquet to a televised confrontation with union leaders. His dinner jacket and bow tie clashed strongly with his words, which stressed that the industry had no money to increase the pay of workers. However forceful his arguments, the visual image left with the viewers was affluent: the two minutes it would have taken to change his jacket, shirt and tie would have paid off in greater public attention to his ideas.

In the visual arts, noise is frequently the result of careless or unthinking lack of attention to detail. The most obvious example would be a set of dirty finger-prints on the otherwise pristine surface of a drawing. The inability to set down *precisely* what you intended is a more subtle form of noise, but it is frequently as effective in distracting the viewer from your intended message. A line which is intended to be straight, but isn't, will have this effect.

Fig. 2.1 Jackson Pollock, *Yellow Islands*, 1952, 56½" × 73". Courtesy The Tate Gallery, London.

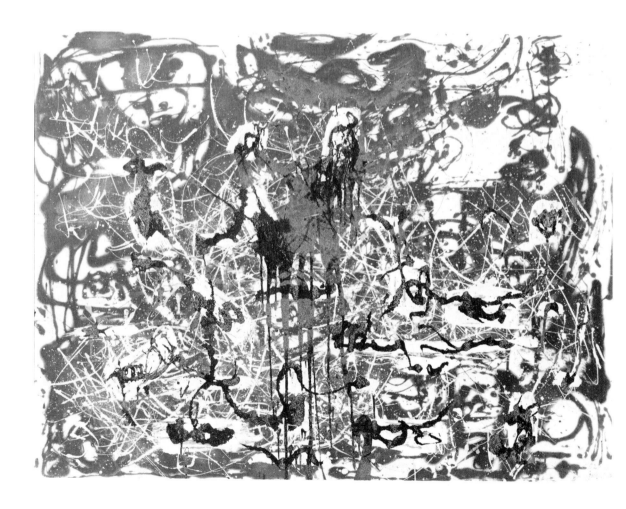

A colour wash which is intended to saturate completely a passage of a painting, and doesn't, will interfere with the message. A photograph which is supposed to be stuck down precisely on a collage, but can clearly be seen to be lifting, will create noise. A badly cut mount over an otherwise exquisite piece of work will interfere with the quality of the communication.

This is not to argue for immaculate, elegant art-work at the expense of freer, more expressive work. Rather, it is necessary to understand that the intention of the artist should be clear. If that intention is to create a rough, unstructured surface for a particular effect, then that is what should appear. When Jackson Pollock threw his paint onto his large canvases, he did it with what was once described as 'the skill of a cowboy with a lasso'. The act of throwing paint rather than applying it with a brush perfectly expressed his intention: in other words, he minimized the noise in his work.

It would be reasonable to claim that, from a communicative point of view, the quality which characterizes all successful artists is their consummate ability to reduce noise in their work. This is as true of Michelangelo as it is of Henry Moore, Andy Warhol, or even a radical artist like Joseph Beuys: although his assemblages are often puzzling, they contain nothing which does not have a contribution to make to the message of the work.

Occasionally an artist will sieze on the problem of noise and make it the subject of a painting. It could be argued, for example, that the dot structure necessary to translate continuous-tone images into printed forms depends upon what would otherwise function as noise. The coarser and more porous the paper receiving the ink, the larger the dot structure must be to avoid clogging the image. Roy Lichtenstein recognized this as a characteristic

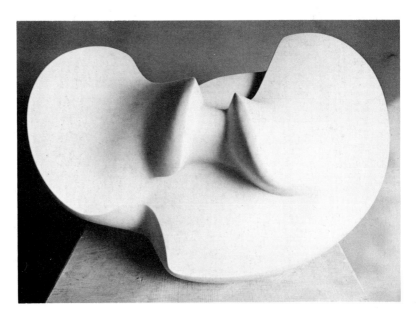

Fig. 2.2 Henry Moore, *Divided Oval: Butterfly*, 1967, 33½" long, white marble. Courtesy The Henry Moore Foundation.

Fig. 2.3 Joseph Beuys, *Monuments to the Stag*, 1982. Courtesy Jochen Littkeman.

element of the print process and exploited it to enormous effect, promoting the previous inhibition of the dot-structure to a key role in a sophisticated painting.

Similarly, an artist may deliberately leave a place for a work to interact with an individual viewer's perceptions so that each receiver makes contact with the work in a different way. This is a risky undertaking, and implies that a firm, clear framework of certainty is offered within which the random elements can be seen to operate.

An illustrator aims to produce a clear image of a hawk which unambiguously presents the important aspects of plumage, shape and habitat. A fine artist who paints the same bird offers an image whose impact alters each time you see it; the viewer's mood or preoccupations interact with those of the artist to produce a complex set of effects.

The hole through a Henry Moore sculpture might provide one viewer with an element suggesting the interaction of the work with its surrounding landscape. Another may see the hole as an essential part of the formal design of the sculpture. Yet another may consider it a demonstration that holes in sculpture are inevitable if the dictum 'truth to materials' is being followed in the making of the work.

Fig. 2.4.A Roy Lichtenstein, *Whaam!*, 1963. Courtesy The Tate Gallery, London.

Fig. 2.4.B Detail from *Whaam!* Courtesy The Tate Gallery, London, © DACS 1986.

All artists of course make assumptions about the level of understanding of the viewers of their work and, consciously or not, leave some passages understated. A splash of blue at the top of a canvas is often sufficient to evoke 'sky', even though our experience of sky tells us that there are many colours of skies, many gradations of colour, and many associated elements such as birds, clouds, movement and so on which make up our experience of actual skies.

Your initial impact, whatever the medium, is vital: if it fails to harmonize with your main aim, you will have to waste a great deal of effort in correcting it. The cover of a book or record tells the purchaser at a glance whether the contents are frivolous or profound, polemical or reassuring, highbrow or lowbrow. The opening shots of a television programme tell us to expect comedy, horror, insight or information, and we are greatly irritated if this expectation is not fulfilled. The first glance at a poster based on a harsh, 'soot and whitewash' photograph leads us to anticipate a certain type of message; a pastel drawing would produce different expectations.

The hard-nosed world of business reflects this in the care and expense which large companies devote to creating the right impression on those who use their services. Walk into the reception area of a mutinational organization and look carefully at your surroundings: colour-scheme, furniture, notices, architecture and equipment express the work of a skilled designer who has been given the task of creating an impression, whether of caution, creativity or dynamism.

Figure 2.5 shows a colour-supplement advertisement aimed at persuading people to buy a house built by a particular firm. It is obvious that a great deal of attention has been devoted to this image. Each element has been carefully selected to contribute positively to the overall message. The colour scheme is warm, selected from a yellow and brown palette. The characters presented by the actors are carefully chosen. The parent is young, clean, happy, and exudes that elusive air of success. What is he? Architect, maybe; graphic designer? A discriminating person, therefore, who has chosen to buy a Sunley home (nothing so crudely materialistic as a house). In the background hangs a pale curtain; the window itself is invisible, but we assume that it is a big picture window such as you might find in an expensive new house. Notice, also, that although the advertisement aims to sell houses rather than house-fittings and furniture, virtually nothing of the house itself is visible in the photograph. The window itself is only there by implication: the whole set was probably built and photographed in the photographer's studio. Nevertheless, the whole image conveys success, warmth and happiness. It is important to remember that when a company decides to advertise and buys a full page in an expensive colour magazine to carry its message, the financial outlay is enormous. The least the

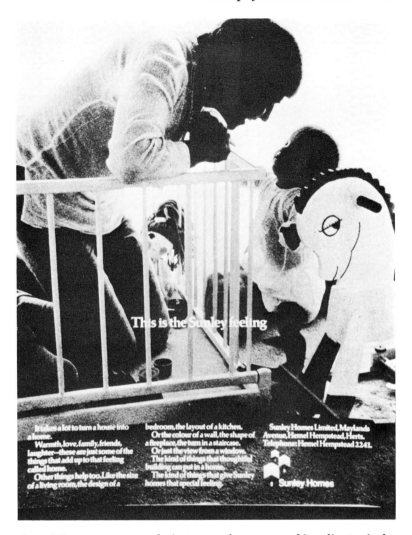

Fig. 2.5 Advertisement for Sunley Homes.

advertising agency can do is to use the money of its client wisely. Remember also that it costs as much to buy the space for a poor advertisement as for an effective one.

Semantic noise is usually under the direct control of the encoder. Physical noise is inherently less accessible to the encoder, but there are usually steps which can be taken to reduce its impact. You can 'shout louder' by using bigger displays, brighter colours, flashing lights, bolder images, and they may have the desired effect; you can repeat yourself; or you can cut your losses and opt for a quieter medium or occasion.

Loss of information in transmission

Shannon and Weaver's model (discussed in Chapter 1) necessarily implies that any act of human communication is less than perfectly efficient. Some portion of our intended message will be lost between the original conception and the impression on the mind of the receiver. The idea will lose (and gain) during the process of encoding; noise will cause some of the signal to be distorted; between decoding and understanding, further alterations may take place.

To make the same point more succinctly: an old saying in the advertising business claims that about 50 per cent of the effort expended in a campaign is wasted, but the trouble is, we do not know which 50 per cent it is!

A playwright puts her ideas into a script of a hundred pages. This is sent to a producer, who likes it, decides to stage it, and briefs an artist to design costumes and sets which will support the meaning and style of the play when it comes to an audience. Each person in the chain reinterprets what they have seen in the light of their own attitudes and experience. They may add to it or detract from it; what is certain is that they will in some sense alter it. Each member of the audience then brings to the performance a set of prejudices and preferences which will modify the impact of the performance. As the auditorium empties, this impact is further modified by the arguments and explanations of friends.

A painter or sculptor exhibits a work. Although the artist is unlikely to have consulted other artists for advice, the work of predecessors and contemporaries will have been absorbed into his consciousness and will form the soil from which this work can grow. Some of the visitors to the exhibition will share his knowledge of developments in the history of art; others will have seen nothing like it before. The artist cannot ignore the difference between the two groups, although one can legitimately choose to address only one of them. Many controversies in art derive from a refusal to acknowledge this question.

When Duchamp exhibited his 'readymades' (Figure 2.6) at the beginning of the century, he fuelled a debate about the nature of art, the reverberations of which are felt today. The greatest exasperation is likely to be felt by those whose experience has not brought them to the point where such a challenge is comprehensible, still less felt to be necessary. Andy Warhol's soup tins and Brillo boxes continue this discussion, as do piles of bricks in major state-supported galleries, submarines built from discarded car-tyres and so on; the argument is meaningless unless you are aware of the earlier works which have fed it. No one can be sure of a safely selected guest-list for an audience; transmission means uncertainty.

The more people you introduce into the chain of transmission,

Fig. 2.6 Marcel Duchamp,
Bicycle Wheel, New York, 1951,
metal wheel 25½″ diameter,
painted wood stool 23¾″ high.
Courtesy the Sidney and Harriet
Janis Collection. Gift to the
Museum of Modern Art,
New York. ADAGP 1986.

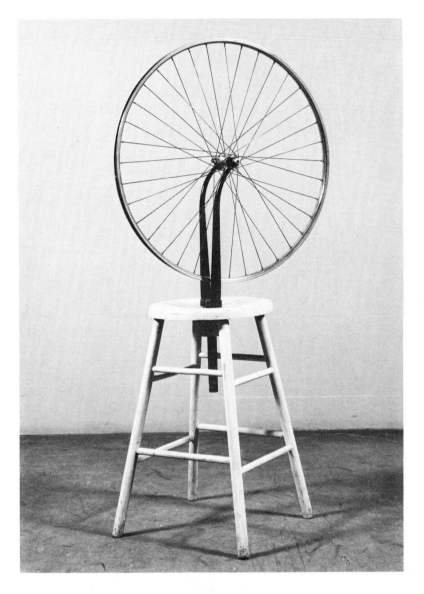

the greater the potential for distortion and therefore the more elaborate the checks you will have to build into the process. However, even a simple message produced by a single designer can overlook potential snags. A poster designed to publicize a programme of early films carried the title 'Silent Classics'. A shop assistant said, as she stuck the poster to the window. 'How can you have silent music?' The author had ignored the fact that for many people, 'classics' has an exclusively musical meaning. Each element in the composition may have had a similar potential for confusion.

In most cases, the cumulative effect of the whole message (the illustration, the names of the films, etc.) irons out the effect of each minor uncertainty. An audio-visual medium, which combines the

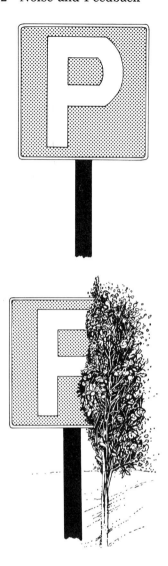

strengths of two channels, has an even greater potential for restating the same point in different ways to reduce the margin of confusion. This process will be considered in detail in the next section.

Redundancy and noise

Consider the following sentences:

> Mothers and small are threatened by . . . health.
> Signals . . . often sent defective lines . . communication.

A moment's reflection should enable the reader to complete these sentences and understand the intended meaning. We prove this every day in a number of ways: by conversing on a poor telephone connection, by completing each other's utterances and by deciphering poor handwriting. The reason we can do these things is that our language has *redundancy* as an essential feature: whether we want to or not, we say most things twice.

Look again at the first sentence. The word 'threatened' carries as part of its meaning the implication that what follows is bad, and so we complete the sentence as 'by poor health', or an equivalent phrase. In the second sentence, the *s* at the end of 'signals' is effectively repeated by the plural element in the word 'are' or 'were' which follows it.

A road sign, such as the 'P' for parking carries its information in a variety of ways. The shape of the letter itself, within certain limits, indicates permission to park; but the shape and colour of the square on which it is painted also convey some information. How much confusion would result if damage or peeling paint changed the 'P' to an 'F'? What would happen if the right-hand side was partly obscured? In both cases, at least some of the effectiveness of the sign would remain.

The mood of a film is produced by the words and the actions, together with the music (or lack of it), costumes, lighting, sets, camera angle and method of switching from one shot to the next. One reason for the powerful impact of film as a medium is that each of these can be carefully planned in harmony, and they are delivered to the viewer in a darkened room with a minimum of distractions. A television play, by contrast, will require much

Redundancy: the inclusion of the same information at more than one point in a message. It may be measured by the degree to which one part of a message can be predicted on the basis of the rest. Redundancy serves as a means of reducing the effects of noise; on the other hand, a completely redundant (i.e. predictable) message is said to carry no information.

of the planning involved in a film (subject to what is normally a smaller budget of time and money) but will be received against a background of distractions – people who switch on in the middle of the programme, family conversation, telephone calls and sorties to the kitchen. In this case, the redundancy of television as a medium becomes vital if the bulk of the audience is to follow the programme: the music tells us when a climax is coming, the pace of the action is reflected in the speed of cutting from one camera to another and in the volume of sound-effects, the identity of the hero is emphasized by type-casting and so on.

For communication to be possible, *the redundancy built into a signal must increase in proportion to the noise in the channel.* By repeating the same message, you raise your chances of overcoming the problems caused by noise. The road-sign which is partly obscured still conveys its information because of the redundancy built into the visible half. If someone coughs in the middle of a conversation, you can reconstruct the missing word from those you managed to hear. The music tells you what is happening when your viewing of the screen is interrupted.

Difficult or unfamiliar material also needs to incorporate a high degree of redundancy, to allow for problems of decoding and interpretation; the last few paragraphs are deliberately redundant because of the authors' sense that many readers will find this concept puzzling.

Redundancy, then, is not an unfortunate restriction of human communication, but a vital asset which enables us to overcome the limitations of the channels available to us. Indeed, it is possible to regard the careful cultivation of redundancy as the mark of a skilled communicator, whether in education, advertising, book-design or journalism.

Feedback in interpersonal communication

The briefest, sparest means of conveying your message is rarely the most effective. You need to consider the psychology of the receiver, who is actively absorbing what you have to say and checking it against previous knowledge. The active listener is constantly evaluating our talk through such questions as:

Does this make sense?
Does this person have an axe to grind?
Do I like this person?
How does this fit in to what I already know?
What am I going to say when it comes to my turn?

When two people are engaged in a conversation, they respond continually to each other's statements: while I recite my tale of

woe, you will make regular brief responses, either through changes in your facial expression or through interjections: 'Uh-huh, oh really, well I never, oh you poor thing, that's terrible.' Without this kind of feedback, my flow of words will probably dry up; I need to have confirmation that you are still listening and that you understand what I am saying.

There is a well established technique in television and radio whereby the interviewer nods encouragingly at the interviewee in order to prevent any hesitation in the flow of words. Even in a television interview which has taken place in the street or in someone's home, the face of the interviewer will appear from time to time asking questions or nodding encouragement; and yet the economics of television are such that only one camera will have been used. These shots are filmed after the interview and are skilfully edited into the final version to suggest a continuous event. Many of these inserts are of the journalist's head nodding: the effect on the viewer at home is that the veracity of the interviewee's statements is supported by the nodding head of the supposedly impartial interviewer.

Anticipated or actual feedback is an essential factor in the psychology of communication, and one which plays an essential part in Osgood and Schramm's (1954) model:

As a representation of interpersonal communication, this has a number of advantages over the account of Shannon and Weaver.

Fig. 2.7 Osgood and Schramm's model of communication.

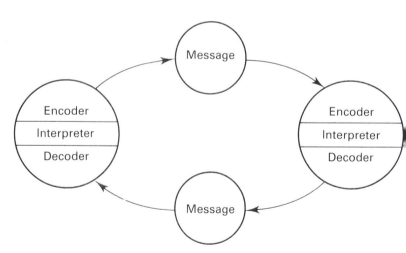

First, it makes feedback a central feature of the process, rather than an optional extra added onto a one-directional basic framework. Second, it is a dynamic model: it helps to show how a

Feedback is the return flow of messages from receiver to sender. It can be either *positive* (supporting or agreeing with the message) or *negative* (criticizing or contradicting the message).

situation can change. In addition, it shows graphically why redundancy is an essential part of the process: since the participants are interpreting each other's signals while they encode their own, they need some spare capacity in the system to leave space for this interpretation to function. Both 'sender' and 'receiver' are modifying their intentions at every point in the exchange.

This model is clearly better suited to the description of face-to-face interaction than to the more remote processes of the mass media, but remnants of the same psychological interaction can still be seen in more distant communication: while I am looking at a photograph, painting or film, I am interpreting it and formulating some kind of response, which may be expressed to a companion or completely internalized to form an element in a later communication of my own. Similarly, photographer, painter and film-maker will at least try to anticipate the interpretative processes of their ultimate audience.

For both sender and receiver, feedback is vital. Without it, the sender cannot be sure if the message has even been received, still less whether it has been greeted with disagreement, disbelief, misunderstanding or bored complacency. There is no way of knowing which points to labour, nor which are likely to be key issues for future development. For the receiver, on the other hand, feedback is the means by which dialogue can focus on more fruitful areas and skip less interesting matters.

Feedback and the mass media

The mass media, such as most of television and the popular press, aim to address a single message simultaneously to the whole population. The organizations which control them include teams of specialists so that each aspect of the final product is the result of a different individual's experience and knowledge, which operates within tightly prescribed limits. To produce a television advertisement, for example, camera-operator, lighting manager, director, actors, graphic artist, set-builder and musicians receive instructions from a team which may even have been employed by a different organization. A marketing analyst will have identified potential customers and their needs.

Clearly, within such an elaborate set of processes, messages are sent and checked in a highly organized fashion: where so much money is involved, nothing is left to chance. However, the success or failure of these people depends not on their inter-reaction with each other, but on the reaction of the world outside. Their efforts are directed at a mass audience which may be far removed from them socially, culturally, intellectually and even geographically. Audience feedback in this context is both precious and difficult to

obtain. It requires skilled and honest attention: the production at which your colleagues cringe with embarrassment may be perfect for your less sophisticated audience, and only field trials will give you an idea of the final effect. Mind you, even these have been known to fail. The advertisements for a beer which 'refreshes the parts other beers do not reach' were a dismal failure on their pilot audience; the manufacturers nevertheless backed their agency's hunch, and the result was one of the advertising triumphs of the decade. The difficulty which professional communicators face with feedback is that their professional and social lives overlap so comprehensively: many of them spend all their professional and social lives with others of the same background.

Levels of communication

Success in communication is rarely an all-or-nothing affair. A rambling and unsteady account may rivet our attention because of the emotional impact of the events it records, and we may fall asleep in a slick and thoughtful presentation because we have no interest in its subject-matter. In evaluating the performance of a communicator, we need to judge success at three levels: technical, semantic and pragmatic.

Technical: how accurately have the signs been transmitted?
An exquisitely balanced use of tone and colour is pointless if the printer cannot reproduce it with the equipment, paper and cost constraints in operation. A filmed advertisement can depend upon detail and textures which are lost on the domestic television set. A photographic negative has a range of blacks, whites and greys which must be reduced when a print is made from it; if that, in turn, is passed to a publisher for inclusion in a magazine, still more has to be lost in the half-tone screen used in printing.

Technical limitations have affected advertisements on colour television, which is very partial in its handling of different colours. Blue, for example, it tends to emphasize: blue eyes, accordingly, stand out. Then there is the variation in the use of the colour control knob; some people prefer high, bright colour whereas others opt for a more muted effect. This can have a drastic effect on the appearance of some products, while others seem unaffected. Beer looks like beer anywhere along the colour-range; not so butter or margarine. Variations around yellow soon become green in one direction and orange-red in the other, and any of these variations are likely to be counterproductive in persuading people to buy butter or margarine. So, while enticing close-ups of beer can feature prominently in an advertisement, butter or margarine is more often represented by a smiling face which has just consumed a mouthful of liberally spread bread or biscuit.

Semantic: how accurately do the transmitted signals convey the intended meaning?

We have already considered the fact that an object suggests many things to different people, but the question is wider than that. We may have overestimated the speed and skill of decoding which our receiver can attain. For each medium and audience there is an optimum rate at which information can be handled. Below this rate we are boring, and above this rate we become confusing. This limitation is a psychological equivalent of the engineer's term *bandwidth*: the bandwidth of a channel is the maximum range of signals which it can carry at one time. Black and white television, for example, requires a much greater bandwidth than radio, but a smaller one than colour television.

The psychological applications of this concept relate more to types of message than to physical channel. Some audiences are more receptive to certain types of message, and can accordingly absorb information from them at a faster rate. One who follows avidly the dress of a social group will attribute meanings which would be lost on others: for some, a tie will instantly proclaim its wearer's former attendance at an expensive school or membership of a prestigious regiment, while for others the cut of a pair of trousers or the colour of a shirt will indicate that the wearer is a fan of a particular pop-group; given this knowledge, the viewer may also be able to infer certain social attitudes. To those without the knowledge of the relevant code, the same point may have to be spelt out in more elaborate detail.

Pragmatic: how effectively does the received meaning affect conduct in the intended manner?

Before the law in Britain compelled drivers to wear seat-belts, there were a number of advertising campaigns to encourage voluntary use. Each campaign was preceded and followed by a survey to measure how many drivers were complying. One campaign was actually followed by a drop in the number of seat-belt wearers: presumably, although the adverts had reached a large audience who had understood the message, something in the manner of the presentation had provoked irritation or disagreement rather than compliance.

If psychology were an exact science, we would be able to account precisely for people's initial attitudes and anticipate exactly the effects of any given message. This is, of course, not so. If we support our case with disturbing or violent images, for example, we may shake our audience's complacency or we may cause tham to turn away and ignore what upsets them. Toothpaste advertisements offering sweet-smelling breath are usually more effective than those which threaten us with oral infection and black, decaying stumps. By contrast, a charity for diabetics reluctantly gave prominence to the image of a child using a hypodermic when the smiling photograph of an attractive young diabetic had failed to produce the right response.

Each case has to be treated separately, but the very professionalism of some media personnel can obscure this principle. They may earn admiration, promotion and even awards for the skill and flair which they exhibit in devising materials which have only a minimal effect on the audience at which they were supposed to be directed. Similarly, the effort which an agency devotes to flattering the chairman of a company may be a necessary way of winning the account, but is often recognizable as the product of an agency running out of ideas or of a client whose vanity risks standing in the way of commercial success.

Communication as process

We started by considering communication as a simple operation like connecting two telephones by means of a wire; now, we are looking at a wider system of interconnections and loops to coordinate a number of impulses from different sources. To say that communication is a process is to emphasize that it is dynamic: it does not have a beginning, a middle and an end. It also uses a system of inputs and connections none of which can be seen as the single element on which the rest depend. Two substances interact in a chemical process which cannot take place in the absence of a third, the catalyst, which remains apparently unchanged; none of these substances can be seen as the cause of the interaction. This notion of process has been summarized in the aphorism 'A chicken is an egg's way of making more eggs': the point at which we choose to begin our description of a process is arbitrary, so that we could equally well begin at another point or with another element.

A notice attracts our attention so that we remember its message: why? The explanation is unlikely to be found exclusively in the notice itself, but in an interaction between an aspect of the notice and the circumstances in which it is found. The notice may be for a radical organization whose work we know; in the window of our staid, respectable neighbour it acquires a new significance. It may use the vocabulary of honour, patriotism and loyalty we associate with other organizations. We may see it after an argument which aroused in us a sympathetic awareness of the cause it seems to promote. In each case, we have to move beyond the notice itself in accounting for its effect.

Each of the components may be modified by the presence or absence of another. We expect to see a gothic typeface in black on a white background; in lilac on a pale blue background it suggests complexities of meaning wider than those of type or colour. 'Rule Britannia' has unambiguous effects as music: but if a television director uses this tune while the screen is filled with images of a collapsing building or derelict factories, the effect is more than the sum of the parts, as one meaning is overlaid by another.

Each act of communication takes its place in a continuing sequence. We communicate as a response to our perceptions of people and events around us; our communication becomes an event which changes the experience of those we reach, and to which they in turn react. The demands which we make of others and which they make of us in exchanging messages can lead to heightened awareness of the possibilities open to us; the experience may then lead us to seek more elaborate codes through which to share these perceptions.

Summary

A message may be distorted through the action of random interruptions in the channel (physical noise) or through some aspect of its content (semantic noise). The effects of noise and of difficulty in absorbing the concepts of a message can be offset by building into it a high degree of redundancy; feedback is a means through which the success of transmission can be assessed. This success itself has several aspects – technical, semantic and effective. The final result comes from the interplay of all the elements in a transaction.

Where do we go from here?

Feedback exercises:

1 Draw a simple design on a sheet of paper. It is better to use abstract, asymmetrical designs made up of a number of separate shapes. Then try to describe the design to a friend who has not seen it; see if he or she can copy your design purely on the basis of what you say. Do not look at this second drawing until it it finished. Try this exercise in two ways: first, without allowing your friend to ask questions, and then with questions permitted.

2 Find two photographs or other images which, together, tell a story or make a point. Write down the message which they represent for you. Then ask a friend to do the same. Compare the results. What third image could be added to remove any ambiguity? Try it.

3 Make an ink-blot pattern on a piece of paper. What does the pattern suggest to you? Add a single patch of a second colour to clarify the image. See if others recognize your intended effect. Gradually modify the image to the point where nine out of ten viewers can instantly recognize it. What effect does the use of a third colour have on this process?

3 Meaning, Connotation and Empathy

The meaning of a message is not fixed and absolute: it is produced by an interaction between the communicator, the recipient and the context. Furthermore, people differ in their sensitivity to meanings, especially if these are implied rather than unambiguously expressed. This responsiveness is related to personal and psychological factors as well as to experience and training.

A group of psychologists were studying the effects of different types of music on the listener. They wanted to know if stirring marches really did quicken the heartbeat, and if soft, languorous pieces produced slower breathing and relaxation of tension. Their results were all that they could have hoped, with one marked exception: a man whose response to a brisk march from Carmen was lethargic and bored. Their surprise was increased when they discovered that he was a music teacher, but this proved to be the key to the whole problem. A piano arrangement of this tune had been a test piece in an examination regularly taken by his students; hearing it was sufficient to evoke excruciating hours listening to the music being tortured by beginners. He understood the intended meaning of the piece, but was not able to respond in an appropriate manner because of the unpleasant memories which interfered with his hearing of the piece.

Connotation and denotation

We give labels to things in order to classify them, to make clearer the meaning we are trying to convey. In simple terms, if we wish to discuss a table it helps communication if we call it 'table' rather than 'chair' or 'donkey'. If we have to teach our listeners new words every time we speak, our conversation becomes tiresomely didactic, so we build upon the language which they already possess – and the same is true of communication through pictures or graphics, as we shall see. However, in using a name or a label which our audience has used before, we evoke not only the meaning we intend but also a varying range of personal memories of other occasions when this word or label has been encountered. This distinction, between a label and the memories which it evokes, is

the traditional one between denotation and connotation.

A photograph of my family *denotes* them: they are unquestionably defined in the picture. The *connotations*, on the other hand, are stimulated by factors such as the viewer's prior knowledge or experience of the characters portrayed. For grandfather, this is a souvenir of the day he drove the family to the seaside in his new car; little Johnnie remembers that this was the day when he got lost, and so on.

Consider these signs:

**Cream Teas
Computer Aided Design**

There is something odd about them. We have seen these words and typefaces many times; both have acquired sets of connotations. CREAM TEAS we associate with rural holidays, picturesque scenery and old cottages. By contrast, the shapes of the letters speak of technology, efficiency and the future. The cause of our unease is made clear when we make a simple substitution:

**Cream Teas
Computer Aided Design**

This time, the signs work more successfully; we have matched the connotations of the words to those of the typeface and the result is that each part of the message reinforces the other. Failure to coordinate text with design is as serious as failure to spell the sign correctly.

Much of the designer's task is concerned with such problems, since every aspect of the presentation will excite certain connotations in the listener. Even the choice of medium must be made in this light: line drawings, photographs, charcoal,

A sign *denotes* that to which it explicitly refers. The *denotation* of a word is what appears in the dictionary as a definition of the word; the denotation of a road-sign is the explanation of its use provided by the Highway Code.

The *connotations* of a sign are the totality of recollections evoked by it; they vary from person to person and tend to be emotional in character.

watercolour, oils – all produce memories and therefore expectations in the viewer. Consider your reactions when you pick up a book of colourful cartoons, and you will understand the courage of the first cartoonist to offer the world the complete text of a Shakespeare play in cartoon form, and that of Raymond Briggs when he attempted to deal sensitively with the implications of nuclear war in the same medium.

Architects and interior designers develop a fine awareness of the connotations of the materials they employ. A shop in the High Street of an old cathedral city was being refurbished for its new owner when the builders came across an old fireplace of rough stone. Should it be blocked up and covered in plaster, or could it be made a feature of the new design? The question could only be answered by reference to the message which the new owner wished to project about the business. Fortunately for admirers of the antique, the shop was to sell high-quality soft furnishings in traditional patterns. The fireplace stayed. If the business had concerned itself with teenage fashions or electronics, it would probably have had to go.

The use of connotation is of necessity an imprecise affair. If we regard visual communication as using a *language*, then every subgroup of a society will have its own *dialect*, and each individual's taste and experience will imply a distinct *ideolect*: a personal variety of the community's language.

Semantic differential

It is in the nature of connotation that it is complex and incapable of permanent definition: each successive use of a word or shape is added to what has gone before, like a series of deposits which progressively modify the shape of the object on which they crystallize. Some of the connotations become so general that they are assimilated into the essential meaning, the denotation, of the message.

Consider the swastika. When Rudyard Kipling adopted it as a kind of personal logo, it was a curious good-luck sign from Ancient Greece and from North India. Later, the German Nazi party adopted a form of swastika on their flags and uniform, still hoping to use its antiquarian function as a charm. Today, no one can use this sign without evoking a memory of Germany in the 30s and 40s and the horrors with which that time is branded.

The mass media are alive to the shifting nature of connotation as they constantly search for new ways to represent their meanings. Narrow trousers and short hair have connotations of adolescent rebellion for one generation; for the next, they suggest middle-aged conformity and must be rejected in favour of something else. New groups seek ways of asserting their collective identity: the

word 'gay' and a whole range of clothes have been appropriated for the needs of people who now feel freer to identify themselves.

If we are to allow for unexpected connotations, we need a way of testing for them; the more expensive or important our message, the more time we should spend on such preparatory work. Charles Osgood developed a system for testing the connotations of individual words, which has been extended to every other kind of message-carrier from television stars to colours, clothes and even events. This system, the *semantic differential*, asks the receiver to rate each item on a series of scales – young/old, good/bad, healthy/unhealthy, etc. You can then measure the actual connotations of your message against those of your intentions.

You might, for example, be asked to design publicity material for a film, like the still of Roger Moore (Figure 3.1). In discussion with the director and the film company, you establish the overall marketing strategy and the central message of this particular advertisement. Let us say that the Moore character is to be fairly young, strong, tough but with a hint of tenderness, efficient and a person with whom the male members of the audience can identify. This would produce an ideal profile something like this:

young		✓				old
strong	✓					weak
good	✓					bad
like me	✓					unlike me
tough		✓				tender
efficient	✓					incompetent

You can now show this picture to a sample of your potential audience, and ask them to rate it on these scales. If you are successful, you will find a fairly close match; where there are discrepancies, you will have either to modify the picture or to couple it with another which will modify its effect. Each potential user of your image will have to re-test it against their own criteria. The toy-maker who is thinking of attaching Roger Moore's name to a new product will have to determine the selling-points to be emphasized, and compare them with the semantic differential profile produced by this image.

The strength of the semantic differential as a tool is that it gives a sounder basis to discussions which would otherwise be impressionistic and often unrelated to the responses of the target

Fig. 3.1 Roger Moore in *Moonraker*, 1979. Courtesy the National Film Archive.

audience. Many advertisements, for example, are produced by people well into their 30s but aimed at a teenage market; the subjective response of the designer is in this case unreliable.

When carrying out such tests, it is vital that the audience should respond to the thing itself rather than the name of the thing. Words often have different connotations from the things to which they refer, and furthermore in describing something you may omit what proves to be a vital element. The connotations of the word 'silk' are easily established; but these may be altered when we see a particular African model wearing an electric-blue silk blouse in an extravagantly fashionable style. You might like to consider the thinking behind the Silk Cut advertisements which used photographs of cuts in purple and white silk to make their point. To an extent these posters are a desperate response to the advertising trade's own restrictions on tobacco advertising in Britain, so that more obvious signs (glamorous people and locations, for example) are not available. The precise designs of the posters aimed to add to the separate connotations of their elements. The responses of smokers and non-smokers, men and women, young and old, would be as different as their connotations for each element.

Sense, feeling, tone, intention

The oldest theories about the nature of meaning focused on the study of words; indeed, such discussions are as old as philosophy itself. In our own century, analysis of the concept of meaning has become steadily more specialized and a number of academic disciplines have developed methods which can help us to come to terms with the visual media.

I.A. Richards (1923), for example, was working within a tradition of literary scholarship when he analysed the term 'meaning' into four elements: sense, feeling, tone and intention.

The *sense* of a message is the external reality which it denotes. The sentence 'My garden needs weeding' refers to the undisputed condition of an area at which I am looking. Goya's drawings of wartime atrocities refer to incidents which he saw, or which were reported to him: the incidents are the sense of the drawings.

The *feeling* of a message is the attitude which it expresses towards the designated reality. As I speak about my garden, you may infer from my voice either that I am not looking forward to the hoeing which awaits me, or that weeding is one of my favourite pastimes. Goya's handling of his subject-matter expresses his horror and revulsion at the acts which he recorded.

Fig. 3.2 Goya, *The Disasters of War*, no. 37: *This is worse* (*Esto es peor*), etching, lavis and drypoint, *c.* 1812. Courtesy the Trustees of the British Museum.

The *tone* reveals the sender's attitude to the audience. In choosing to discuss the state of my garden with you, I may be admitting you to the intimate circle of people with whom I am prepared to discuss my domestic affairs. Goya's drawings imply an audience who would share his attitudes to war, but who were perhaps unaware of the precise nature of what had been taking place.

The *intention* of any signal is the effect which it aims to produce. In talking about my garden, I may be softening up a colleague to cover for me so that I can go home early. Goya's intention in his drawing is quite clear: to excite such revulsion in his audience that they will seek to prevent a recurrence of the incidents portrayed.

Richards's analysis of meaning is of particular use, as he intended, in justifying the distinction between personal, expressive work and that which has a more narrowly commercial purpose. In considering the work of the photographer who produced the Roger Moore picture on p. 34, for instance, sense and intention are clear, tone is more ambiguous, and feeling is totally suppressed. The photographer would probably have argued forcefully that the intrusion of his personal feelings towards the subject would have been 'unprofessional', an argument which you may wish to ponder.

The weakness of all such analyses as these is that we cannot attempt to enter into the mind of the communicator in any direct sense; we make inferences about intentions by combining our subjective response with such background information as we can obtain about the circumstances of the message's production and the personality of its creator. In extreme cases, this has led to criticism which devotes itself more to biography than to examination of the works in question. This tendency has been firmly corrected by the structuralists, whom we shall consider in the next section and who aim to reveal the innate structure of each work that they examine.

Structural meaning

It has become commonplace to use such phrases as 'the language of painting' or 'the grammar of interior design'. This is because we have come to recognize the connection between all of the systems by means of which we communicate; the key to this link is the definition of a *sign* as *any physical entity to which a community attributes meaning*. Words, clothes, gestures, possessions, pictures, colours – we give meaning to all of them in our daily interactions. The group of theories which groups all of these signs was named *semiology* (US: *semiotics*) in the pioneer writing of Ferdinand de Saussure, where it was defined as 'the science which studies the life of signs in our social interaction'.

The sign has two aspects, which may be reflected in the form:

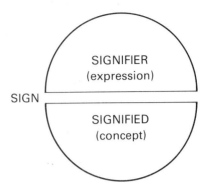

The *signifier* is the physical entity which expresses the sign: the sound, shape or texture. The *signified* is the concept or emotion conveyed by the sign. The words 'You may park here' and the blue-and-white sign P are completely different signifiers, but each of them expresses the same signified. Signification, the link between expression and concept, depends upon rules, codes, which are tacitly accepted by a community, and these rules are the area which semiology seeks to explore.

Signs rarely occur in a fragmented, isolated fashion; if they did, the possibilities for human communication would be much more limited. The interest of semiology lies in its account of the structures within which signs may be combined. Consider these tables:

Harry	is was	the	best worst clumsiest weirdest	draughtsman	I	have ever had	known

short-sleeved shirt long-sleeved shirt tee-shirt string vest denim jacket	trousers shorts	socks no socks	sandals shoes	pants

From each of these tables, it is possible to produce a set of items which a community will accept as normal. The sentences, 'Harry is the best draughtsman I have ever known' and 'Harry was the weirdest draughtsman I had ever known' are both well-formed sentences in the English language. Similarly, within British society it is acceptable for me to go shopping in summer wearing tee-shirt, shorts, no socks, sandals and underpants. In both cases, there are limitations on the places where each item can occur (shirt

covers shoulders, 'the best draughtsman' but not 'the draughtsman best'). Provided the basic rules of combination are followed, the act of pronouncing that sentence or of wearing those items of clothing will be accepted as a reasonable communication.

```
                        was
                 weirdest I have
                 the known Henry
                 draughtsman ever
```

```
        Henry was the weirdest draughtsman
                 I have ever known
```

Such a combination is a *syntagm* – the fusing of several signs into a single, complex, act of communication. The other dimension of structural meaning is provided by the options from which selection is made at each point. Such a set of options is called a *paradigm*. The complete list of words which could replace 'best' without damaging the structure of the sentence is one such paradigm; another is the alternatives which I might wear instead of trousers without causing amusement or embarrassment.

Clearly, as the above examples have shown, any syntagm will be composed of paradigms which differ in the number of options they include. In the clothing example above, the option 'socks/no socks' is a *closed set*, that is, a list which presents a known and limited set of options. By contrast, the choice 'short-sleeved shirt' is from a longer list which it is impossible to catalogue in detail: an *open set*.

Planning and analysing visual messages in structural terms can clarify many problems. For example, it will be apparent that in order to convey more complex meanings, we can use either syntagms which are relatively complex or those which include relatively long paradigms. If a printer can only offer a choice of black, white or grey, this closed set offers fewer communicative possibilities than another with a wider range of colours, shades

Structural meaning is that part of the meaning of a sign which is established by examining its relationship with other signs; it ignores any reference which the sign might make to 'reality'. There are two aspects to structural meaning, paradigmatic and syntagmatic.

Paradigmatic meaning is the relationship between one sign and the others which could correctly occupy its place within the rules of this system of communication. *Syntagmatic* meaning is the relationship between a particular sign and the others with which it is combined to produce a single act of communication.

and textures. Such a limitation may be offset, however, if another paradigm of the message is longer – the range of typefaces, say, or print sizes.

This emphasis on structural meaning has a radical effect on the study of the arts and the mass media. By its emphasis on expression rather than intention, and on the development of unified theories which cover all the media, structuralism has permitted reassessments of many cultural products whose effects had been overlooked; it has also enabled critics to bring together disparate products whose authors would have claimed that their intentions were markedly different. Oil-paintings, glamour-photographs and posters, for example, may all use images of women; by paying exclusive attention to the structures used in all three, it is possible to highlight common features about the use of women as signs and to disregard conscious motivations in favour of a revelation of routine, shared practices. These routines may be more important than expressed intentions: a photographer may be unaware of the ground-rules which have been subconsciously assimilated over years of education, training and experience, and since these ground-rules are more general in their operation, they are accordingly more important than the opinions of one person.

It is not possible here to consider structuralist approaches in detail; all we can do is to indicate a general approach and to suggest further reading. Much of the writing in this field, however, can become highly subjective in its approach and is often characterized by flashes of brilliant and original insight obscured by a tangle of rebarbative jargon.

Part of the problem is caused by the need to consider the total impact of a piece of work without resorting to biography or the self-explanation of the author. To do this, we need to establish the 'grammar' being used – to consider the structures made by the combination of different elements, and to establish what range of options was available at each point; in this way, we may hope to clarify a range of principles of which that work is an example.

If, for example, we wish to study the significance of a particular photograph by a photographer whose work we know well, we cannot do so without relating it to the rest of his work (to establish the language of signs which he uses). It will probably also be necessary to examine the setting in which a particular photograph is used – the layout of the particular magazine, the routine practices of that publication, and the similarities between those practices and those of other magazines. All this is clearly a major undertaking.

Consider the photograph overleaf. What does it mean?

Posed in this way, the question is impossible to answer; all we can describe is its actual effect on us as viewers, bringing to it our knowledge, attitudes and understanding of how photography works. A woman is walking along a rain-soaked pavement. Ignoring for the moment the central figure, we think about the

concepts signified by the setting. If we have visited London, we may recognize the type of housing: respectable, middle-class. If we know anything about the fashions of the late 1930s, her clothes are indicators of social class and attitudes: respectable, matronly camouflage. Her facial expression is stern and slightly suspicious, and this is emphasized by the low camera angle which makes her (in both senses of the phrase) look down on us. The flat tonal range of the print emphasizes the drabness of her surroundings. The wet pavement implies rain, which to one familiar with the British winter climate signifies dull monotony. The feeling which we infer depends on our attitude to women in general and to people of the social class which we take her to represent: we may be hostile, sympathetic, admiring or scornful.

Any meaning we have produced so far is subjective: it depends on our knowledge and our state of mind, not on that of the photographer. If we were to discover a relationship between photographer and subject – husband, employer, subordinate or friend, for example – we would use this knowledge to confirm or modify the judgements we had previously made. It would also be

helpful to know something about the purpose for which it was taken, or the way in which it was subsequently used.

Bill Brandt took this photograph in 1939 as part of a photographic report entitled 'The Perfect Parlourmaid', one of many which he carried out during his years working for *Picture Post*. The title given to the report helps us to fix the meaning of the picture, though even here we are influenced by our attitudes to domestic service. The report consists of 21 photographs, each anchored by its own caption, and a short text.

The first caption reads:

> A Pillar of the Stately Homes of England: The Head-Parlourmaid. She is the senior member of the staff. In many of the stately homes she has taken the place of the butler. She enjoys the complete confidence of 'the family', and, through her, it is possible and proper for 'the family' to express their wishes to those 'below-stairs'. She has the bearing of a Guardsman and the discretion of a diplomat.

The ideas, vocabulary and even punctuation of this passage deserve attention as careful as that we give to the photograph – note the capital letter for Guardsman which is denied the more cosmopolitan diplomat.

All the photographs, apart from the one we are considering, show Pratt, the parlourmaid, in uniform and, apart from two of them, they portray her tasks in the household. This contrast is an important element in the meaning of the image of her in her outdoor clothes, which bears the following caption:

> Taking Her Afternoon Off
> Every Wednesday, Pratt has her 'half-day'. She leaves at noon and makes straight for London, whence she visits friends at Putney. She does a little shopping, sees a film, and is back again by 10.30.

The contrast between this photograph and the others is heightened by a technical detail of printing technique: in the magazine, the tonal range of the print has been reduced by the use of a soft photographic paper, producing a muted effect by contrast with the crisp contrasts of the remaining, indoor, shots. This serves to heighten the interest of the portrayal of Pratt's role in the household and to emphasize the drabness of her life outside. (The point is underlined by the quality of the print as reproduced some 30 years later in Brandt's retrospective collection 'Shadow of Light', where a hard paper is used and about a third of the picture is cropped, emphasizing the dominance of the woman. We must again infer a change of intention with the passage of time.)

At this point we may think that we have identified a 'meaning' for this picture; what we have in fact done is to offer a range of different meanings which could be still further extended when we

set the whole report in its context within the magazine, or within Brandt's total output before and after taking this shot. The meaning intended by the magazine's editor can be calculated by relating this essay to the other articles, layouts, and even advertisements in the magazine – is the editorial tone radical or conservative? What other images of women are offered in text, photographs and advertising? Brandt's intention may be deduced by studying the subjects he covered and seeing how far they depart from the norms of the magazine; or by contrasting his '*Picture Post*' commissions with his other work.

In carrying out this analysis, what we are doing is emphasizing patterns and regularities of treatment, not asking what Brandt was 'really' saying. If we extend the analysis to include the similarities between Brandt's 'language' and that of less famous press photographers, we enter one of the areas of bitterest controversy. Criticism in the arts is much concerned with the notion of 'greatness': to establish the semiological rules which link, say, Renoir with the designers of advertising hoardings is felt to diminish him as a painter. To emphasize the way in which a painter uses the connotations, conventions and attitudes of contemporary society is at least as important as to study his/her biography or brushstrokes.

Arbitrary and motivated signs

The link between signifier and signified, between the expression of an idea and the thing itself, is usually *arbitrary*: there is no essential reason why it must signify this idea rather than a host of others. In English, we use the letters DOG to signify an animal which others represent with totally different signifiers: CHIEN, HUND, and so on. In speech this arbitrariness is obvious, but we can often be deceived into believing that visual communication is less arbitrary.

Consider this sign:

Our culture has taught us to recognize this immediately. The pointing index finger directs our attention to the left; we do not need to be told to ignore the three fingers which are tucked into the palm and which point the other way. Since childhood we have seen signs like this, and heard spoken comments which reinforce its meaning. Gradually, we have been able to extend our understanding so that when we are presented with this sign:

We have no hesitation in labelling it 'vertical arrow' and in understanding that it directs us forwards (unless we encountered it by a staircase, in which case we might expect it to direct our attention upwards). That it could equally well be used to signify 'umbrella' or even 'house' does not even occur to us.

Arbitrariness is relative, not absolute: in some cases we may feel that the link between signifier and signified lies to some extent in the nature of the signifier itself. A stylized drawing seems less arbitrary than the word DOG; the pointing hand is less arbitrary than the vertical arrow. In these cases, we speak of the sign being relatively *motivated*.

Motivation and arbitrariness constitute a dimension along which two signs can be compared. A colour photograph is a more motivated sign to indicate the concept 'dog' than is a stylized outline; a moving film is still more so.

It is important to remember that what we treat as a universal sign-system may be totally incomprehensible in a foreign culture, in the same way that a friendly gesture in one culture becomes an obscenity in another. The skull and crossbones is widely used as a warning sign on poisons; in another culture unaware of our pirate tales, its meaning may be misread. Indeed, the pirate tales themselves have changed so much that the sign has failed to deter English children who associated it with a comic character from a popular television cartoon. When health workers in Kenya, for whom the concept 'dangerous poison' was important, studied how well ordinary people understood this sign, they found that those

who recognized it were outnumbered by those for whom it meant anything from 'Sign of the medical department' to 'A Catholic Church'.

Aberrant decoding

If we listen to someone speaking a foreign language, we cannot pretend to understand what they are saying. We may be entranced by the music of a new way of talking, but we are unlikely to delude ourselves that anything more profound is taking place. The same is not true for visual communication: the London architect who admires the famous Benin bronzes from Nigeria may express enthusiastic appreciation, but be unaware of the gulf between the sculptor's intentions and his own response. These works were produced by craftsmen as part of a total religious and social system of which the English city-dweller of the late twentieth century is totally unaware; the scientific beliefs and knowledge of a vast range of other art-forms which the trained English eye brings to these bronzes leads only to an imitation of communication. *Aberrant decoding* takes place whenever the code used by the receiver differs markedly from that of the sender. Where sender and receiver are from cultures separated by time, distance, religion or ideology, aberrant decoding is almost inevitable; it may, however, produce interesting results – Picasso and Henry Moore both profited greatly by such experiences, the one of African art, the other of neolithic European sculpture.

Today's intellectuals who enthuse about the cowboy films of the 1930s cannot possibly view them in the same light as the John Ford or Howard Hawks who made them. John Wayne's role in *Stagecoach* can no longer be seen without an awareness of the way subsequent films picked up this part and others and turned them into stereotypes; nor can we fail to recall the persona which Wayne himself developed in the rest of his screen career. Furthermore, our attitudes to violence have been modified by the guilt engendered by Belsen, Nagasaki and a succession of wars and civil disturbances from Algeria to Northern Ireland, each of which has affected our consciousness through mass-media images.

At a less dramatic level, when we see an advertisement made for television as little as 30 years ago it often seems quaint or ludicrous because our reading of visual codes has been developed by a lifetime's exposure of film and television. One result of this change in awareness is the occasional practice when media professionals meet of viewing old television advertisements as a kind of comedy film. Today's producers and consumers are no more intelligent than their parents or grandparents, but they have been taught to make connections which 20 years ago would have had to be laboriously spelt out.

Empathy

We all know a good listener: the kind of person you approach when you want to talk through an apparently intractable personal problem. You go not expecting any really expert advice, but knowing that this person will be able to imagine how you feel, to understand what you are trying to express while at the same time retaining the neutral perspective of a sympathetic outsider. *Empathy*, the ability to project oneself into the mind of another person while listening, is a complex mixture of psychological flexibility and skill at interpreting signs. It requires a number of deliberate strategies on the part of the listener: complete attention, a refusal to look for quick and easy ways of classifying the message, the ability to suspend one's own prejudices and to resist the fatal temptation to break in: 'That reminds me of when I . . .' Such a self-effacing manner is rarely the product of an insecure personality, but usually reflects a confident inner strength.

Responding to the visual arts depends upon empathy of a very similar kind. Creative and original communicators depend upon novel ways of presenting new messages, and call for patience and a preparedness to wait for the work to reveal its own standpoint. The

Fig. 3.3 Nazi prison camp at Belsen, 1945. Courtesy the Imperial War Museum.

notorious 'I don't know much about art, but I know what I like' is an admission of a failure of empathy: the development of visual awareness requires an enthusiastic curiosity about new forms of expression, even if a considered reflection leads one to conclude that the enthusiasm was in this case misplaced.

Innovation is essential, at least as a means of holding our audience's attention and persuading them that we have something interesting to say. Some artists hold our attention by skilfully impersonating the mannerisms of a bygone age: the imitation is the message. At the extreme of this tendency lies Kitsch, art for those who do not wish to risk assessing an experience which is novel or even troubling. For this reason, it builds upon the extremes of established Good Taste. The 'Venus de Milo' is indisputably Great Art; therefore a platinum reproduction of the Venus must be an exquisite piece. A fallacy of course, equivalent to saying that if x is good then 2x must be twice as good. To make an aesthetic judgement, or to make a genuinely subjective response to an image, it is not enough to apply the formulae of other people; you must have the courage of your own convictions.

The mass media have, in the last 100 years, played an important part in bringing 'difficult', innovatory work to a place of acceptance within our society. Impressionist paintings which were once excluded from the established galleries now adorn chocolate boxes; pop videos incorporate techniques which 20 years ago would have produced earnest head-scratchings at the Institute of Contemporary Art and other havens of the avant-garde. Every label which we learn to use can work against the kind of empathy we are recommending: to dismiss a work as 'kitsch' may reflect a mind just as closed as that of the popular journalist who ridicules the Museum of Modern Art for its latest problematical exhibit.

Extracoding: undercoding and overcoding

How does empathy work? Clearly, the receiver is adding a great deal to the superficial meaning of the signs which are being transmitted. The imaginative insight which is required can be broken down into a number of separate processes. To start with, the receiver may be unsure whether there is an additional level of intended meaning at all, and will test half-formed theories as more of the message is revealed. This testing will often include the ability to make connections where none has been expressed – connections with previous messages, or with shared experience beyond the immediate transaction. In decoding a message we will without prompting devote a great deal of our attention to tracing these links, and the addition which we make in this way both widens and enriches the scope of our communication.

Extracoding, the process on which empathy depends, has been

analysed into two elements. The first, *undercoding*, is a move from potential code to actual code, as when a traveller in a new country sees a new form of behaviour and guesses that it probably has a particular significance for the local inhabitants. With each new occurrence of the behaviour, this guess is progressively modified. Faced with the Middle Eastern habit of tilting back the head to indicate 'no', our traveller will at first be led into arguments through interpreting it as a nod. The need to revise this interpretation gradually becomes clear, and after a series of such incidents the gesture is recognized not as 'yes', but as 'no'.

A similar task faces us when we are confronted by the work of an unfamiliar painter. We are surprised, perhaps, by a particular use of colour and are unsure whether it is significant or simply the by-product of other, more important factors. As we see more of the painter's work, we are able gradually to make a firmer interpretation of the colour's significance.

The second process, *overcoding*, reflects the fact that a message is usually greater than the sum of its parts. Through overcoding, the receiver makes connections between the different features of a message so that we can infer meanings which are not present in any of the separate units. When a friend says to you, in front of a group of less congenial acquaintances, 'Well, I must go now,' a brief glance directed at you may be enough to make you understand that you are being asked to leave as well. Duchamp's readymades and much of conceptual art require an act of overcoding on the part of the spectator: as well as the syntax by which we interpret the form of the object itself, we must also take into account the place and the circumstances in which it is seen.

Roy Lichtenstein, in appropriating images normally reserved for commercial print processes and by producing a fine-art image for exhibition in a museum, demands of his audience a sophistication of understanding, an overcoding which recognizes the significance of the statement in relation to other developments in contemporary art.

All but the most routine of our communication depends on a mixture of under- and overcoding, and it is this dynamic interaction which provides the basis for empathy. For the sender, the links implied by a message may be obvious. The receiver, however, will have to recreate those implicit connections through a process of undercoding. At the same time, in seeking to reconstruct the sender's pattern of meaning, the receiver may initially be uncertain whether any relationship is intended and will explore these potential meanings through overcoding.

Humour, irony and the skilled use of quotation are all techniques which depend on extracoding; the pleasure involved in the exercise of all three is the teasing awareness that the receiver may fail to see the connections we imply.

Marcel Duchamp's celebrated pastiche of the *Mona Lisa* demonstrates this wittily. By adding the letters LH00Q to the

Fig. 3.4 Marcel Duchamp, *L.H.O.O.Q.*, 1919 (Paris), 7¾″ × 4⅞″, pencil on a reproduction. Courtesy Alain Tarica. The Museum of Modern Art, New York. © ADAGP 1986.

bottom of the picture he demands extracoding in the viewer. The letters, as letters, are meaningless, and yet their inclusion implies meaning. In fact, the *sound* of the French letter names gives an irreverent interpretation to this most solemn of Renaissance images: they echo the sentence 'Elle a chaud au cul', or 'She has a warm backside', a novel explanation of the mystery of her smile.

Extracoding is also a concept which helps to illuminate the traditional distinction between design and the fine arts. The craft

tradition of the designer builds upon overt purposes to resolve any ambiguities of function: clarity, certainty and utility are the hallmarks of this approach. At the other extreme, the fine arts have played with our ability to enjoy ambiguity and to create a personal response. The products of this tradition do not impose limits around the ways in which they can be used.

Turner's magnificent painting of a storm at sea, although initially related to its title, is very much more than that. His use of colour evokes a multitude of responses in the viewer, and the painting transcends mere narrative.

Many artists have borrowed commercial images to re-present them to a different audience. We have referred earlier to Lichtenstein and his plundering the world of comics for his imagery. Andy Warhol likewise enhanced the common soup-label by giving it a fine-art context within which to operate. Considerable talent is required to lift an image from one context and fix it securely in another. The definition of such strategies is the work of the critic; to enjoy them is the pleasure of the viewer.

Meaning: systems in contact

It should be clear from what we have been saying that there is no way in which one can talk of 'the meaning' of a sign. Each party to a transaction has to negotiate the meaning which fits their knowledge and needs. In defining meanings, we will often say more about our own preoccupations than about the message we seek to analyse. Beneath all the definitions of the word 'meaning', a common element is the notion of two systems in contact. Where they overlap, meaning can be produced; if they fail to touch, meaning is impossible.

The railway timetable overlaps with my plans for a day in the big city; for me, today, that is its meaning. Goya's drawings impinge upon my feelings about war, about human nature, about Spain and even about Goya's personal history. As my preconceptions change, so do the meanings of the messages I receive. Empathy is the ability to widen the area of potential meaning.

Summary

The vagueness of the term 'meaning' arises from the wide range of purposes for which it is used. Sender and receiver see different things in the same message. Previous encounters leave traces which affect the meaning of this communication. One message can work simultaneously in a number of different ways, so that in decoding it the receiver has to infer connections which may not

have been made explicit. This decoding is not infallible; in adding to the message so as to explore its potential meanings, the receiver may be displaying a talent for empathy or the self-deception of aberrant decoding. One solution to this dilemma is to analyse a message in terms of its similarities to, and differences from, other messages in related media: according to this approach, the meaning of a message lies in the structures of which it is an example.

Where do we go from here?

Much of the writing within the semiological tradition is obscure and personal, or else depends on a detailed understanding of sociological theory. The most comprehensive account of the theory is Umberto Eco's *A Theory of Semiotics*, (Macmillan, 1977) but this is not a beginner's book. Roland Barthes wrote many illuminating essays on the subject, of which the most famous collection is *Mythologies* (Paladin, 1973) (in which 'Myth Today' is essential reading). An easier introduction to his ideas is *Image, Music, Text* (Fontana, 1984). John Berger's *Ways of Seeing* (BBC/Penguin, 1972) is a stimulating attack on traditional art history from a similar viewpoint. On the relationship between theories of art and studies of ideology and society, the clearest and most useful study is Janet Wolff's *The Social Production of Art* (Macmillan, 1981).

4 Selection and Communication

'A fool sees not the same tree that a wise man sees.'
– William Blake: *Proverbs of Hell*

We pay more attention to, and remember, messages that we like. If we are faced with a message we dislike, or which fails to confirm our prejudices, we tend to ignore those parts which make us uncomfortable. For example, if we dislike or mistrust the source, our interpretation of the message is likely to be hostile. In all this, first impressions are vital. If we begin with a false idea about the purpose of a communication, such an initial error is unlikely to be corrected, and mistakes may snowball.

Anyone who has used a tape-recorder knows how much more difficult it is to avoid background noises than they might have expected. In addition to the voice, there is a storm of other sounds of which you were unaware when making the recording – the hum of the central heating system, rustling papers, someone whistling in the corridor. On the other hand, you can exclude a great deal of distracting noise from your attention when you are getting to know an attractive stranger at a party, concentrating single-mindedly on the words being spoken. Unlike simple recording equipment, human perception is brilliantly selective: you can ignore almost anything you want to, but the sound of someone speaking your name will cut through a forest of other sounds. This selection is vital for human development if only because we have to respond to a continuous flood of messages, and one brain can handle only so much information. What is more, we have to lump things together into broad categories and treat them as the same until they are proved different: not even the most fastidious philosopher will treat each new event as totally distinct from all that has passed before, but will infer similarities and thereby know how to respond.

Selective attention: choosing messages we like

You want to watch the television for half an hour; you have no newspaper to check the evening's programmes, so you just switch

from one channel to another until you find something you know you will like. Nothing in this situation is surprising – except the speed with which it is possible for you to make your choice. You classify programmes according to a set of personal rules: favourite or detested categories of programme, types of actor, country of origin, and so on. The opening minutes of any programme are carefully designed with this in mind; the signature tune, graphics, locations, acting and editing combine to show the audience what kind of programme they are to expect. The rest of the programme will reinforce this first impression. Each new shot will be read in the light of expectations generated by what has gone before.

The degree to which we accept this use of *genre* is illustrated by the skill with which some comedians break the rules: in the middle of a show by your favourite pair of comedians, the stage may be set for a horrific graveyard sequence, but you refuse to take seriously this setting of fear and dread, and smile in the expectation that the situation will be transformed by some ludicrous antic.

Graphic design is often used as a means of addressing the selective attention of the audience. Packaging, whether of washing-powder, books or records, gives us immediate information about the nature of the contents. A heavy-metal LP with its sleeve embellished by a straightforward copy of a famous old oil-painting, for example, will attract only the most determined purchaser.

It is conceivable that you are reading these words in this book because some, at least, of these concerns have preoccupied the publisher of this book. It would be interesting to try to analyse why you have reached as far as this with us: what made you choose this book in the first place? Why did you persist?

We occasionally encounter graphic presentations where unexpected juxtapositions are deliberately sought – where an 'old master' is reproduced deliberately to appeal to the sophisticated knowledge of its inappropriateness on the part of a potential purchaser. This might be referred to as graphic irony – a pretence of ignorance regarding the inappropriateness of an image.

The initial impact of a message may be deliberately manipulated

Genre is a category of mass-media production which operates within a distinct set of rules. In the cinema industry, for example, films are recognizable as musicals, comedies, thrillers, horror stories, westerns, science fiction, and so on. Novelty may be achieved by combining the elements of more than one genre – a comedy with a western setting, a science-fiction horror, or a historical epic with musical elements.

In painting, the genre used by an artist may be the subject-matter chosen – landscape, portraiture, still life, and so on, each of which has its own history and precedents. There is also, confusingly, a specific type of painting, referred to as 'genre painting', which deals with everyday life rather than heroic or mythological subjects.

by the designer. Few employees, for example, ever bother to read a company report, although it may be of far greater importance to them than to the shareholders who normally study it. Knowing that the resulting ignorance can have a serious effect on industrial relations, some firms now give careful thought to the production of documents which are less intimidating to those untrained in accountancy. Prose descriptions of statistical trends, or even tables of figures, deter most readers; colour, charts, cartoons and the rest of the graphic designer's repertoire can make the essential points more accessible. Some firms with more money to spend even produce their own video programmes which are shown to staff during working hours to achieve the same end. The purpose of each method is the same: to overcome the selection process which would normally filter out the information which we seek to transmit.

Scanning is the rapid survey of our environment which precedes close examination of those details of most concern to us, and it serves the useful function of saving us from wasting our time with irrelevancies. Designers, particularly those concerned with graphics, study the processes involved in scanning in order to make the important parts of their messages coincide with them. In designing an English page-layout, for example, we know that the reader's eye will first encounter the middle of the page, then move to the top left, top right, bottom right: anything in the bottom left hand corner will be reached last. Newspapers use this knowledge in their placing of important stories; they also know the right-hand page will receive precedence over the left.

Selective perception: what we see means what we want it to mean

We direct our attention mainly to those messages we know we will like: they suit our tastes, confirm our prejudices, or excite our indignation in ways which appeal to our self-esteem. Selection does not end there, however. When we are presented with a complex message, we are likely to notice particularly those parts of it which confirm our previous attitudes. For most of us, it is important to protect ourselves against the need too often to come to terms with contradiction; only a confident or a blinkered person can keep opposing viewpoints in mind at the same time.

If you are to affect the opinions of those with whom you disagree, you will have to present your ideas in such a way that, to start with at least, these ideas appear to confirm their most important values. As a minimum, you need to avoid antagonizing them by the very appearance of your message. You have to construct a kind of Trojan horse, whose attractive appearance causes the defender to open the gates and let it in. Once within the

fortifications, the subversive ideas can be released to achieve their purpose. If new ideas do not fit neatly into old ones, *cognitive dissonance* is the result; for most of us this is uncomfortable, and we may solve the problem by rejecting the new idea.

A favourite ploy of politicians and other persuaders is initially to proffer opinions and views to an audience with which they are most likely to agree – 'This is a fine town,' 'The future of our children is important' – before moving on to more contentious propositions: 'What this town needs is a nuclear power station.'

Unlikely though it seems, a similar process operates when you go to an art-gallery. Your experience, education and training have given you a set of preconceptions about painting; perhaps you have been taught to expect that any painting which gives slavish attention to the naturalistic presentation of detail is unexciting and unimaginative. When faced with a painting by, say, Landseer, you pass on to something more innovative in appearance. When you come to a Dali, the surface features push you in two ways: the passages of photographic detail alternate with dream-like structures, texture and light which persuade you to look longer. This is possibly why most people are ambivalent in their attitudes to Dali, since in some of his work the 'traditional' surface features are felt to predominate, while in others the 'surrealist' style is felt to represent a more genuinely experimental approach. First impressions establish the framework within which the ambiguities of a work can be interpreted.

A carefully argued pamphlet will be unlikely to persuade any but the committed if the layout is clumsy, the printing poor and the spelling erratic: the initial impression is slapdash and this will colour a first reading. A demonstration may be impassioned and exuberant; but if the visual impression recorded by the cameras is of a group of irresponsible eccentrics, then that is how their case will be regarded. The photographic or video image leaves a lasting impression; words alone are much less effective.

Now look at the picture of a tank opposite . . . and study the caption which explains its meaning. Do not read the next paragraph until you have done so.

Cognitive dissonance is the theory that people feel uncomfortable when faced with contradictory information or viewpoints and therefore tend to seek out messages which confirm them in choices or verdicts which they have reached.

Fig. 4.1 The purpose of the photographer and the publisher of this picture seems self-evident: the tensions operating in a civil conflict are neatly encapsulated in the rugged and menacing design of the machine and the reassuring banality of the surrounding domestic architecture, a message heightened by the harsh photographic quality of the image and the almost surrealist unreality of the composition. A further level of analysis of this photograph is explored below.

In discussing the meaning of a photographic image the central problem is that, as we have said before, the meaning is not in the message but in the people who are communicating. You will have inferred from the way we have treated this photograph that there is something odd about it: this strangeness lies not in the photograph but in the caption. We have written a caption which anchors this photograph in a particular way and within a particular genre: that of the dramatic news photograph with pretensions to artistic consideration. In fact, the first time we came across this photograph was in an advertisement for Calor Gas, where it was fixed by a rather different caption: 'Calor Gas is a Camper's Delight'.

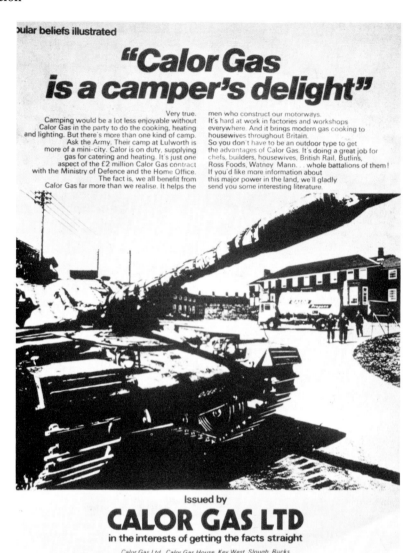

Thus, although it may be partly true that the camera never lies, photographers are occasionally guilty of adjusting the facts or making them appear more tidy than they really were. The people who employ them are often guilty of downright lies for which they can rarely be prosecuted, but which are often more damaging than words. A telephoto lens can frame two people in earnest conversation although they were in reality 10 feet apart and talking to other people who do not even appear in the shot. Careful cropping can isolate an action from its context and allow the viewer to be led to questionable conclusions; and yet with most people the camera retains its reputation for impartiality.

As Barthes (1973), the structuralist, wrote: 'Formerly, the image illustrated the text (made it clearer); today, the text loads the image, burdening it with a culture, a moral, an imagination.' A photographic image is a small slice taken from an event; its

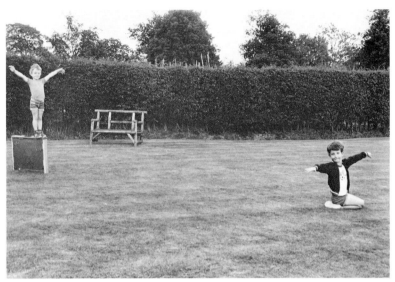

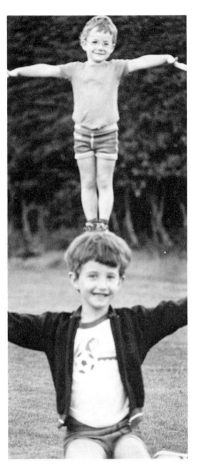

relationship to the event is unclear to the viewer, and can be fixed in a variety of ways by the captions which are attached to it. Consider the photograph in the Calor Gas advertisement: how different would the captions be if it was reproduced in a Republican magazine, a British Army recruiting leaflet or an arms-manufacturer's publicity?

There are, then, two ways in which we can use the audience's need to select. We can design a Trojan horse, or we can do the opposite, emphasizing the content of a message so as to be sure of reaching those who are already favourably disposed towards it.

Fig. 4.2 Two viewpoints: the same scene.

Selective recall: remembering what we want to

There is a famous psychological experiment in which Carmichael, Hogan and Walter (1932) presented the following shapes to two groups of people:

Bottle	⌂	Stirrup
Crescent moon	☾	Letter "C"
Beehive	⏢	Hat
Eyeglasses	⊙—⊙	Dumbbells
Ship's wheel	☼	Sun
Gun	⊳—	Broom
Two	Ƨ	Eight

One group were given the labels in the left-hand column simultaneously with the viewing of the shapes; the others were given the words in the right-hand column. Later, both groups were asked to draw the shapes as they had remembered them. In a large proportion of cases, the shapes had been altered in accordance with the label given. For example,

was changed so that it became either more like this:

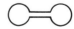

(dumbbells) or like this:

(eyeglasses)

Selective recall such as this can play a vital role in the final effectiveness of any act of communication. If simple shapes such as these can be altered by our preconceptions, how much more so might a complex sequence of film or an intricate illustration be changed in our recollections by strong prejudices or misleading commentaries?

This concept also does much to explain the bitter disagreements which can sometimes divide witnesses to the same incident or viewers of the same television programme. The incident or programme is seen through a filter of previous experience and belief which can subtly emphasize or reduce certain features. Once again, the designer may have to anticipate the perceptions of an antagonistic or insensitive audience.

Television programmes which aim to change children's attitudes have been found to be largely ineffective when presented in isolation; the comments of an adult (parent or teacher) which accompany or follow the programme have a decisive influence over the total impact. (Disadvantaged children may actually miss the point of many television programmes in the absence of adult commentary.) For this reason, some evangelists are reluctant to release videos or films of their campaigns to general audiences: in the hands of a hostile introducer, the result can be completely reversed.

Gestalt: filling the gaps

Look at these two illustrations:

How would you describe what you see here? Unless you are very unusual, it is likely that you will have said that there is an eye in one and a row of three squares in the other, although strictly speaking all that is on the page is a collection of irregular blobs and 10 identical but disconnected straight lines. The organization and pattern is not on the page but in your brain.

That we seek to organize what we see into meaningful wholes is a remarkable but essential feature of the living brain, and one which still distinguishes it from the electronic computer. Artificial intelligence requires every last detail to be ponderously spelt out. We categorize and select from our perceptions on the basis of minimal information. Our visual system represents the acme of this ability: it has been said that the programme which would enable the computer to recognize a table would take months to write, and yet the machine would still have problems with a picture of a horse or a stool.

Such notions sit uncomfortably with the ways we have been taught to think of visual perception, particularly since the Renaissance artists developed their theories which came to give the eye almost the status of a scientific instrument. The eye is not simply a passive, receptive channel passing objective information to an unquestioning brain: it also responds to overriding principles laid down in the brain.

Gestalt psychology, which studied human perception of form and pattern, has produced a growing body of experimental evidence of this interaction. A couple of examples will have to give the flavour of much research, which has taught us that experiences are not fragmentary, but are perceived as organized wholes. We group certain features together and ignore others. We close gaps in order to create simple or satisfying shapes.

It is possible that much of the deep satisfaction or aesthetic pleasure derived from a whole range of art forms is attributable to the brain's willingness to add to the presented stimulus. The perception of the most abstract forms, visual and auditory, is then a product of both the stimulus and the information which the viewer or listener brings to the experience.

Any photographer soon learns about the phenomenon of colour temperature. An ordinary electric light bulb gives light which is yellow in comparison with daylight. On the other hand, the light

falling on the shady side of a building is not only weaker but also bluer than that on the sunny side. A colour photograph will record these differences; most of us notice this change so little that a trainee photographer has to be taught to see it. This contrasts with the experience of people blind from birth who gain their sight in later life. They know by touch how to recognize objects such as eggs, potatoes and cubes of sugar, but have to be taught to recognize their visual appearance. When the same objects are shown in coloured light, the learning process has to begin again.

Optical illusions are a clear example of the brain's refusal to accept without modification the evidence of its eyes. Consider the following pattern:

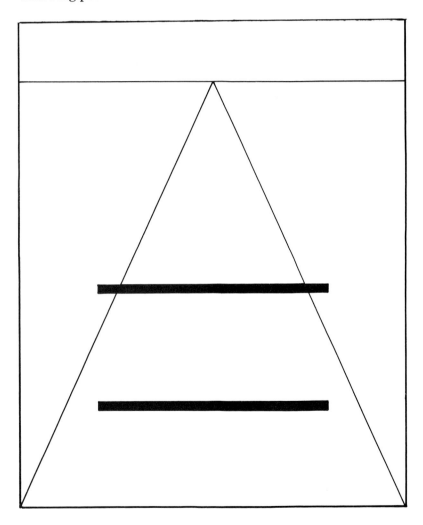

Which line is longer? They appear to be of different lengths, but if you measure them you will find that they are the same. What seems to have happened here is that experience has taught us a general rule which we have over-generalized. The usefulness of the

rule in most of our experience is shown when we see these four lines incorporated in a scene which we recognize:

Given the fragmentary nature of much human communication, this eagerness to create meaningful connections is a great asset. We do not need always to spell out the point of a message; often we can largely predict the organizing processes which will come into play. On other occasions we can leave openings which can be completed in a variety of ways, allowing a freer rein to 'extracoding' (Chapter 3, pp. 46–9) through which the receiver can combine different elements to produce tentative or novel meanings.

In an experiment first devised by Leeper (1935) using drawings very like these the ways in which design can guide the perceptions of the viewer were illuminated. He showed either A or B of the three drawings opposite to each of his experimental subjects.

All of the subjects were then shown drawing C.

Those who had first looked at Drawing A reported that Drawing C showed a young woman; those who had seen Drawing B recognized an old woman. Other studies have revealed more general processes, such as an ambiguous rat/man drawing, which is seen as a rat if preceded by exposure to other rat drawings.

Cohesive devices in communication are those tricks which we use to make clearer the structure of what we are trying to say. A good speaker starts by giving his audience a clear idea of the main lines of the argument which he intends to develop, so that they can keep this framework in their heads while the detail gradually unfolds. Miller, in his work on the psychology of communication, uses the phrase 'the magic number 7, plus or minus two' to suggest the outer limits of what the human brain can grasp at any one time. If you want me to understand a concept which brings together 20 ideas in a particular relationship, you are wasting your time if you try to plough through steadily from one to 20: far better to group them in sets of seven, seven and six and then show how the three groups fit together.

Graphics can provide most effective cohesive devices, for example by keeping the eye aware of the overall shape of the argument while the ear is filled with significant detail, or in a document by emphasizing the nature of what is being said in the colour, texture and layout of the print and illustrations. Most of a page might be left blank in order to focus attention on a key sentence; or a paragraph might be moved out of alignment with the rest of the text for the same purpose.

Sequences of images

One of the principles of gestalt psychology to which we referred in the last section was closure: when faced with a set of lines which almost meet, we imaginatively close the gaps in order to combine the lines into a simple, coherent shape. A similar process affects us when we are shown a succession of images. Since Melies

discovered the art of film editing in the early 1900s, allegedly by restarting a camera which jammed while he was filming traffic passing the Arc de Triomphe, audiences have gradually been taught how to interpret sequences of images.

Consider these three images, which might be taken from the opening moments of a film:

We link these by assuming that the woman is looking at the clouds, and that the threatened storm makes her run for shelter; and yet there is nothing in the pictures themselves to show that she can see the clouds, nor that the first and last pictures come from the same location. Our tendency to imagine that we have seen connections which are in fact the product of our own imagination

makes the work of the stunt-man much easier: a close-up of the star, a long shot of someone falling from a building, a medium shot of the star lying sprawled on the ground – and we think we have seen the star falling from the building.

The subtlety and complexity of the closures which we perform is illustrated by the difference between the simple narrative structures of the early silent films (often helped by captions stating what now seems obvious) and the rapid transitions of a pop video or television advertisement.

Photographers and newspaper editors have exploited our habit of closure to an extent which often borders on cliche. If you take two pictures and arrange them carefully, accidents of composition or content can lead to an effect which adds an element present in neither: this addition is called 'the third effect'. Politician in thoughtful pose, gorilla in identical pose – result, laughter. Starving baby in stricken community, rich youngsters throwing food about – result, indignation. There is still room for the third effect to operate, but our jaded sensibilities now need more careful handling.

A logical sequel to the 'third effect' is the attempt to capture two images in the same photograph, so that the juxtaposition is both more immediate and more penetrating than is the case with two separate pictures. Photomontage, pasting part of one photograph onto another, was developed as a political weapon by John Heartfield in Germany during the Nazis' rise to power. It is still used effectively today, as when Peter Kennard took Constable's idyllic painting 'The Haywain' and glued a cruise missile onto it.

In a previous chapter, we emphasized the diversity of possible responses or meanings for a message; to this we have now added an awareness of the receiver's ability to fit an initial viewpoint to what is seen, emphasizing or ignoring things according to need. In the next chapter, we shall consider one kind of external constraint which can focus our attention: the codes or languages through which our culture communicates.

Summary

Previous experience, prejudice and the brain's preference for simple explanations all colour the interpretations which we give to the impressions of our senses. In order to help the audience focus on those parts of a message which are intended to be important, some attempt must be made to anticipate these selective processes; however, at some times these processes can be anticipated so that we sketch key points and leave the receiver's imagination to close the gaps.

Where do we go from here?

The most striking examples of the tricks which can be played with our perceptual system can be found in the work of M.C. Escher, who delighted in impossible but apparently logical images. Most general textbooks on psychology include a chapter on visual perception; the subject was explored by R.L. Gregory in a number of books, notably *The Intelligent Eye* and *Eye and Brain* (Weidenfeld & Nicolson, 1971, 1977). A more comprehensive introduction to the perception of television programmes is given by Patricia Marks Greenfield in *Minds and Media* (Fontana, 1984), which also analyses the effects of computers on children.

Optical illusions and puzzles (such as close-up photographs of objects taken from an unusual angle or in isolation from the context in which we usually see them) can tell us a great deal about 'normal' perception. It is interesting to set out with a camera to produce an honest but unrecognizable image. An obvious technique is the use of wide-angle lenses from unusual positions or angles – especially the vertical – but careful cropping or observation of the effect of light and atmosphere on colour can produce subtler effects.

5 Cultures, Codes and Conventions

Few, if any, of the signs which we use have meaning in themselves, simply because of what they are: they have the meanings which we or our societies have given to them. In Europe and in North America, people wear black to signify mourning; in other parts of the world, they wear white or even red. In other words, the link between a signifier and the concept which it signifies is arbitrary, governed by a more-or-less random choice by a community rather than by a law of nature.

When you are dealing with others who share your sign-system, this arbitrariness causes no confusion, and it is easy to slip into the unthinking assumption that there is some kind of necessary connection between the two aspects of the sign, signifier and signified. When the receiver comes from another culture and gives to your message an unexpected interpretation, or blank incomprehension, you are reminded of the artificial nature of the *codes* which you use.

Codes and cultures

Jung, the great Swiss psychologist, described how he visited a remote people who had had no previous contact with modern technology and showed them an illustrated magazine. Much to his surprise, they were unable to recognize that the photographs depicted people but regarded them as meaningless smudges. Finally, one of the group traced the outline of a 'smudge' and declared to a disbelieving audience that it represented a white man. And yet, as Jung makes clear, this failure of understanding was produced by defects of neither intelligence nor eyesight. Each of these men was a clear-sighted and efficient hunter. As the psychologist commented when comparing himself to one of these

A *code* is a system into which signs are organized, expressing rules agreed (either explicitly or implicitly) by a community. Languages, genres, artistic conventions, legal systems – all are examples of different types of code.

men, 'His psychic functioning is the same – only his primary assumptions are different.'

We are trained by our culture to perceive the world in a certain way, and this process is so effective that we can often fail to imagine that alternative perceptions are even possible. Our very language plays a part in this. Some scholars (notably B.L. Whorf, the famous amateur student of American Indian languages) have claimed that a language embodies the experience of a people and that each generation of children who learn it is brainwashed into accepting the culture's view of reality. In learning English, for example, we absorb a complex system of tenses which gives us a preoccupation with time. The verb 'go' appears in a host of different forms, each of which relates the event to time and to other events in a special way: goes, is going, went, had gone, would have gone, had been going, and so on. An Arabic-speaking child, by contrast, simplifies this to a much shorter list, which we might represent as 'going', 'went'. A Turkish child would need to include whether the speaker had seen this action, or is simply passing on what another person said.

Each of us grows up in a society which is ordered in a characteristic way. The child who grows up in an apartment in the Bronx or in Liverpool is surrounded by straight lines and right-angles, and may well have a limited range of visual experience when compared with the daughter of a Nigerian cattle-farmer, whose house is circular and who spends her day handling a wide variety of organic shapes. It is almost impossible to measure the effects of such differences in upbringing, but it seems at least likely that hand and eye will achieve greater fluency with the shapes they experience most frequently.

Perspective and some alternatives

Renaissance artists developed the study of perspective as a mathematical exercise, with vanishing-points, ground-lines, eye-levels, and so on. The invention of the camera obscura, which projected an optical image onto a drawing-table, seemed to confirm the scientific objectivity of the technique. However, we should be wary of accepting this with any degree of finality. Mathematics and physics have offered us new ways of projecting reality; the psychology of perception has changed our ideas about the brain's understanding of relative sizes; and photographers have shown that lenses can play tricks with our expectations.

Culture is the system of beliefs, traditions and habits through which a community identifies itself. Language, laws, religion, values, shared habits and tastes are all aspects of culture.

The rules of perspective are built on the assumption that a larger image will seem to be closer to the spectator than a smaller one. This is very far from being an invariable rule. The Kenyan study to which we referred earlier (Chapter 3, pp. 43–4) also tested the villagers' ability to decode a picture which depended on perspective, such as the following line-drawing:

Nine-tenths of the respondents failed to recognize this as a picture of a man spearing an antelope: they recognized the individual figures, but did not link them in this way. Not having been exposed to the conventions of Western art, they had no reason to follow its rules.

In Edinburgh, Bower has carried out a series of experiments with new-born babies to see if they respond to the actual size of an object or to the size of the image which it produces in the eyeball. (The eye has a lens which operates rather like that of a camera.) It is perhaps surprising that, even at the age of a few days, the babies were easily able to distinguish a large cube further away from small cube which was closer. Both cubes produced identical images on the eyeball: the response of these infants, too young to have been taught how to see, clearly indicated that the laws of perspective did not reflect their view of reality. In order to distinguish between the two objects, the babies had to use more complex cues than those of image-size: parallax to estimate relative position, sensitivity to the tiny muscle-movements which focus the lens in the eye, and so on.

In pre-Renaissance art, relative size was a factor not of distance but of importance: in a religious painting, the holiest figure was larger than the others, regardless of distance. The soldiers standing on the walls of a castle were drawn as tall as the walls themselves, regardless of their relative height in life. They were larger because they were the important elements in the picture.

Fig. 5.1 Altarpiece: *The Coronation of the Virgin with Adoring Saints* in the style of Orcagna. Central section only, *c.* 1343, on wood. Reproduced by courtesy of the Trustees of the National Gallery.

The altarpiece shown in Figure 5.1 shows this technique clearly: the angelic figures at the bottom of the picture are less important, and so smaller, than Jesus and Mary, and are accordingly painted less than half as big. In Renaissance art, their position would indicate relative closeness to the painter's viewpoint and they would be represented much larger.

Chinese art is the product of a tradition still older, and one which is remarkable for the subtlety of its means of expression. Here too, perspective in the Renaissance sense is absent except in the most marginal ways. Distance is indicated by the vertical placing of objects on the page, not by size: a figure 200 metres distant is likely to be the same size as one at half that range. The foreshortening of Western art is largely absent, so that parallel lines are not made to taper.

The effect is like that produced by a telephoto lens, which seems to place everything in the same plane. We are all familiar with the 'flattening' effect of powerful telephoto lenses used on television cameras. A long shot of a goalkeeper, for instance, shows him apparently only a short distance in front of the crowd when in fact he may be up to 20 or 30 feet away.

This is probably a reflection of the extremely narrow angle at which the eye registers accurately: if you stare at a fixed point, your sharpest vision is only two or three degrees wide. Try this little experiment. Take a coin and hold it at arm's length. Focus on the wording at one point on the edge of the coin. You will notice that it is not possible clearly to distinguish other wording on the coin without re-focusing your eye.

Unlike a photographic image, the eye's perception of the world becomes increasingly blurred as it moves away from this narrow beam. Chinese painting gives a far more accurate reflection of the flattened depth of field seen by an unwavering gaze. To take in a complex scene closer at hand, the eye learns to make a series of complex scanning movements, best represented in art by the 'joiners' produced by David Hockney: dozens of small pictures, each showing a tiny part of a scene, which are laid out on a plain background like a half-finished quilt.

Perspective, then, is a code: an arbitrary way in which we choose to record and communicate our experience. It is purely conventional: it depends upon tacit acceptance by the members of a given culture, and other cultures may use other means to convey the same message. Since the conduct and perceptions of any group are likely to have been regulated by the same sets of conventions since childhood, they are likely to imagine that their codes have absolute validity. In the same way, we might mistakenly be

Conventions are codes (in both senses: rules of behaviour and systems of signs) which are obviously arbitrary, i.e. governed by the choice of a community rather than by a necessary connection with reality.

inclined to regard medieval European, Chinese or African artists as lacking the accuracy of our methods.

Dress, colour and gesture

It is notorious that communication problems occur in what has, misleadingly, been called 'body-language': gesture, posture, facial expression, touch and personal space. Arabs and South Americans, for example, feel that a comfortable distance apart for two people engaged in friendly conversation is less than half a metre, while in England this would be uncomfortably close and would be intrusively intimate. In most of Europe, black is the colour of mourning, but many Indians use white for the same purpose. Each community will justify its choice in apparently absolute terms, but the usage is purely conventional. Black may be the colour of night, but then white is the colour of ashes and the bleaching out of livelier colours; and what about the connection between red and blood?

Travellers are often embarrassed by the offence which they cause with gestures they take for granted: when you are in Greece, raising both arms in the air, palms forward, is as rude as the V-sign, palm backwards, would be in Britain. Nevertheless, in a foreign country whose language you do not speak, you depend heavily on gesture, and some basic form of communication is usually possible.

Beneath this surface of shifting, arbitrary codes, it may be possible to find a few universals of non-verbal communication. Individual signs may not work across a cultural divide, but sequences of action and the combination of several channels may help to reduce confusion. Thus when touch, eye-contact, posture, facial expression and gesture are used in coordination the ambiguity of each separate one may be reduced.

Eibl-Eibesfield studied the signs of flirtation, surely a universal human pastime, in a number of widely separated societies. She found that in France, Samoa, Papua, Japan, parts of Africa and South America, a girl flirts with the same sequence of actions, which we shall list for those who wish to study the subject for themselves. The girl smiles at the object of her interest, quickly jerks her eyebrows upwards and then turns her head to one side as she lowers her gaze; sometimes she will then peep back at the other person through the corners of her eyes and cover the lower part of her face.

Throughout the world, some gestures are seen as threatening or assertive, such as the 'baton' gesture which chops downwards with the side of the open palm, or with a closed fist and extended index finger. Similarly there have been attempts to suggest subconscious universals in the use of colour. For Freud, black

Fig. 5.2 *Pilgrims and travellers in a landscape.* Detail of wall painting in Cave 217 (P170) Tunhuang. T'ang Dynasty, 8th century. Courtesy of the Percival David Foundation of Chinese Art.

white and red were the primary colours since they were linked to three significant bodily substances: excreta, semen and blood. Blue and green are generally the colours of the sky and of vegetation, but beyond this simple connection the habits of each society will overlay such associations with rich secondary meanings.

The colour-code of western Europe was established by the ritual of the expanding Roman church, whose priests used robes of different colours to mark the mood of the different festivals. In a largely illiterate society, the medieval church used ritual, painting and sculpture as important media of instruction. To these were added an elaborate *hagiology:* the lives of the saints were recounted as messages for the faithful, and each saint was given a set of signs by which he or she could be recognized. This kind of practice is similar to many theatrical traditions, from the shadow-puppets of Indonesia to the Noh plays of Japan and the dramas of American television. The costume, gestures, face and voice of each character tell the audience how to feel about the role being portrayed.

Most popular drama depends upon this kind of instant labelling of characters. The early film industry faced this problem, and had no sound and only the simplest of captions to support its narratives, but both in Europe and in America film-makers were able to build on an existing set of codes using dramatic gesture, costume and setting: those of the melodrama, popular theatre and music-hall. As other cultures developed their own film industries, they built on similar foundations; the Indian film industry, for example, could draw upon long traditions of dance, popular drama and Hindu hagiology.

The existence of these codes is immediately apparent when you watch a silent film, or a modern television drama with the sound turned off. We may smile at the heavy build, thick moustache and swaggering manner of the villain in a Chaplin silent, or the simple contrast between the heroine and the wicked temptress, but the signs of today's Hollywood dramas will seem just as crude to the next generation.

Painters and theatrical designers use colour with great care to indicate their feelings towards a character. Sometimes this is by means of a code which has its sole existence within the play, and is therefore transparently conventional. The director of a production of Shakespeare's *Antony and Cleopatra* wishes to emphasize the

Hagiology, originally 'the recording of the lives of the saints', has come to denote the visual code which enables the religious community to identify the subject of a painting. Thus, in European art, a golden disc around the head is the mark of a saint; a saint who is carrying a bunch of keys in St Peter, and so on. The importance of this code is that it tells the audience what their attitude should be towards the person depicted.

contrast between Antony's army and that of Octavius, and to group the Egyptian characters with Antony. The colour of the costumes is an obvious means of emphasizing this grouping. However, the designer may wish to go further and comment on the nature of the difference between the two groups. If Octavius' friends are dressed in blue and white, but Antony's army and the Egyptians wear green and brown, the audience may see Octavius as harsh and cold, and endow his opponents with earthy sensuality.

Conflict within a character may be suggested by using layers of clothes in contrasting colours: a woman whose unobtrusive manner belies a passionate nature may wear a red dress under a grey coat. If the design is made skilfully, the audience will respond without being conscious of the means used. Once a technique becomes obvious, it risks becoming a joke and, like the white hat and white horse of the early cowboy heroes, will have to be abandoned in favour of a less obvious approach.

Shared codes and social bonds

Visitors to a foreign country who meet a fluent speaker of their own language tend to trust and feel warmly towards that person. We make the subconscious assumption that the person who shares our language will also share our attitudes and values.

Much of adolescent culture is built on this assumption. Teenagers are notoriously unsure of their own identities, and many try on styles of music, dress and conversation as a way of experimenting with new roles. In order to be accepted by a new group, the first requirements are to dress like them and learn to imitate the characteristics of their speech. Young people are not the only ones who are sensitive to this: an adult starting work in a new organization will often have an acute eye for the norms in force. In an advertising agency, for example, the divide between creative staff and account executives is often emphasized by dress, and an inappropriate choice of ostentatiously fashionable or carefully sober clothes may produce unfavourable comment.

An organization can emphasize the degree of conformity and obedience it requires of its members in the way it deals with the matter of dress and hair-style. At one extreme stand the police and armed services, whose personnel are subject to daily inspection for any sign of deviance; acceptable standards of hair-length, dress and cleanliness are explicit and rapidly enforced. Youth workers on the other hand, although conforming to more complex and less obvious codes, have a much looser definition of their professional role and this is reflected in the lack of interest which will be expressed in the dress of junior colleagues.

The pleasure of conforming to the code of the group is partly that of imitating people you admire, but it also tells others how you

Fig. 5.3 Francis Bacon, *Study after Velasquez's Portrait of Pope Innocent X*, 1953. Courtesy Francis Bacon/Des Moines Art Center, USA; Coffin Fine Arts Trust Fund.

wish to be treated. Within the overall code, there will be subtler variations to allow for finer distinctions. These may be compared to the variations within a language known as registers. A *register* is a variety of a code or language which is appropriate to a specific situation. Thus, for most of us there is a range of situations in which we would swear only under the most unbearable provocation – delivering a lecture to a large and serious audience, perhaps, or talking to one's grandmother. There are, by contrast, other situations where we would feel less inhibited in our choice of words – sitting in the cafe with friends, perhaps. Such an ability to adapt to the demands of the situation is a measure of communicative skill, and an analogous ability can be seen in matters of dress. It is neither hypocrisy nor emotional instability which makes us behave in this way, although it may be seen as satisfying the need to emphasize one's attachment to the group and its norms.

Fig. 5.4 Velasquez, *Ritratto di Innocenzo X*. Courtesy Arte Fotografica/Galleria Doria, Pamphilj, Rome.

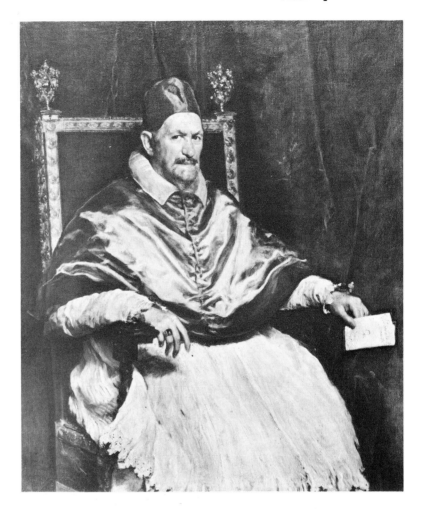

Visual quotation

Every act of communication, however original its message, builds on existing codes and connotations. Without them there would be no communication. However, we can often recognize a specific precedent for the message before us, and we talk of plagiarism, quotation or parody. *Plagiarism* is the dishonest passing of the ideas of another as one's own work; one has neither adapted nor added to the original. *Quotation* is a sharing with the audience of a parallel to a previous event, like Francis Bacon's use of a famous Velazquez portrait as the starting point of his own tortured images. The audience's memory of the original is a counterpoint against which the new image is played. In *parody* this parallel is used for humorous effect, and usually as a means of ridiculing the original.

The briefing of a designer or art director often begins with a form of quotation. The general effect required may be indicated by

Fig. 5.5 Low's TUC carthorse,
April 1946. Courtesy
The Standard.

showing a picture or a design which embodies some of the qualities
needed. The quotation may be lost in the final version, or survive
as an important layer of connotation. For example, the team who
worked on a new television series were referred to a number of
black-and-white American films of the 30s and 40s, and told to find
an equivalent style which would work in the very different context
of colour television. This was a simple use of quotation; more
innovative possibilities might be suggested by considering a
synthesis of the work of two artists. Pop artists like Richard
Hamilton, Lichtenstein and Warhol use quotation just as much as
artists of the classical period used their audience's knowledge of
Greek and Roman myths. Today, however, the myths used tend to
be those of Hollywood, television, advertisements, popular music
or the comic strip. Cartoonists, too, regularly need to make points
through existing codes and connotations; they frequently make
reference in their drawings to other artists and events. Low, the
brilliant cartoonist working in England during the Second World
War, devised a carthorse to symbolize the Trades Union Congress.
This reference has frequently been used by subsequent cartoonists
wishing to evoke the ponderous, plodding nature of some
personality or event.

Quotation at its most effective is even more specific than this.

Pop Art was a movement to use images and conventions from popular
teenage culture in Europe and America as the basis for painting and
sculpture. Comics, advertisements, film-stars, packaging and cars
provided source materials.

Fig. 5.6 Philip Zec cartoon: 'The price of petrol has been increased by one penny. Official.' 6 March 1942, *Daily Mirror*. Courtesy Syndication International Ltd.

During the Second World War, a famous cartoon portrayed a sailor clinging to a life-raft, with the caption 'The price of petrol has been increased by one penny. Official' – a reference to the appalling cost of running the convoys which kept Britain alive at that period.

Fig. 5.7 Cartoon after Zec by Les Gibbard. 6 May 1982, *The Guardian*. Courtesy Les Gibbard.

During the Falklands campaign, when the first ships had been sunk, a *Guardian* cartoonist repeated the picture, and changed the caption to read 'The price of sovereignty has been increased. Official.' The parallel provoked a storm of protest – one sign of an effective cartoon.

Structuralist writers, when considering a phenomenon such as genre (see Chapter 4), analyse the signs being used and the ways in which they are combined to draw conclusions about the general principles or structures which underlie them. Thus a phenomenon such as quotation would be interpreted by them as a special instance of signification: in the above examples, the cartoonists have simply taken an existing sign from the code known by the audience, and combined it with another to form a new paradigm.

Post-structuralist writing has moved on from this to incorporate an awareness of the role of pleasure and of social processes in changing meaning. A producer and an audience share an awareness of a set of genres – western, situation comedy, science fiction, and so on. The producer can use this shared knowledge in one of two ways – either to stay carefully within its rules, or to play with the audience's expectations by manipulating them. A *text of pleasure* is a mass-media product which conforms entirely to the audience's expectations. It allows the audience to relax in the secure knowledge that they will not have to question those assumptions, nor will they have to adjust to a sudden switch. What began as comedy will not suddenly turn into thoughtful documentary. By contrast, a *text of bliss* unsettles the habits and expectations of the audience. It may manipulate the conventions of a genre in order to help the viewer reassess the assumptions on which it is based. The first product of such discomfort is often amusement, but if carefully handled it can also lead to a change in the viewer's own tastes and values.

The gallery system, for example, implies a certain definition of the nature and purposes of art – such notions as financial value, skill, painstaking thoroughness, uniqueness, or solitary and thoughtful contemplation. Duchamp's readymades and the landscapes of *conceptual art* upset this definition, the former because they depend upon the process of selection rather than creation ('This is art because I say so') and the latter because they are inherently worthless as they cannot be collected and sold.

Realism

In a war film, it is easy to distinguish the Americans from the Germans, even though all their lines are in English. When two people speak to each other in English, but with a German accent, we know that they are 'really' speaking German: the use of accents

Conceptual art emphasizes content at the expense of form: what matters is not the specific object produced by the artist, but the processes by which it was produced. The concept behind a work of art is what matters; the materials used are unimportant, and are often ephemeral (body-painting, junk, etc.).

is a convention of the genre, which does not disturb us because we have grown up with it. We also accept without question the convention that if we hear a character speaking while the picture on the screen shows the same character with motionless lips, what we hear are the unspoken thoughts of the character. We give little thought to the illumination of the scene: we may recognize that this is supposed to be a night-time scene, but rarely consider where the light in a particular shot is supposed to be coming from, unless it is particularly obtrusive. However, the details of military uniforms and equipment must be painstakingly exact, or the producer will be inundated by complaints about the film's lack of realism. This fastidiousness will not extend to the medical field: a badly concussed soldier who stands up and within 30 seconds is energetically involved in combat will pass without comment.

The very act of portraying an event or scene involves us in manipulating reality: we simplify, we organize, we explain what is not immediately apparent in order to help the audience understand what is being presented or in order to maintain their interest.

The photographic study by Bill Brandt, and the captions which anchor it, seem stilted and unrealistic by the standards of more recent journalism; yet a glance at this week's magazines will reveal a similar use of selectivity and the imposition of a journalist's habits and viewpoints. Whenever we see a report of a place or a person we know, there is a moment of surprise that it is so different from our own way of remembering the subject.

The painting *American Gothic* by Grant Wood was considered a striking piece of realism when first seen in 1930. Its surface is naturalistic: it reflects more or less accurately the surface of what it records. However, the total composition is carefully contrived to achieve a particular design. The shape of the heads, for example, appears to have been altered. Its realism lies in its use of an everyday subject drawn from the experience of the Americans who first saw it; Brandt's study is another effort in the same direction, and some of his other work was even more engaged with the ordinary life of his contemporaries.

Each generation rediscovers *realism*: there is a reaction against the conventions of earlier image-makers, and this produces a feeling that now it is possible to make a more direct and somehow 'honest' portrayal than those of the past. We are misled into thinking that modern films, stories and pictures are more realistic that those of 30 years ago because ours are less artificial and contrived. The novelty of today's conventions blinds us to the ways in which they manipulate experience to make it intelligible.

The essential fallacy of much discussion about realism is the

Realism is the theory that art should approximate to reality: to imitate historical events, believable characters or familiar experiences.

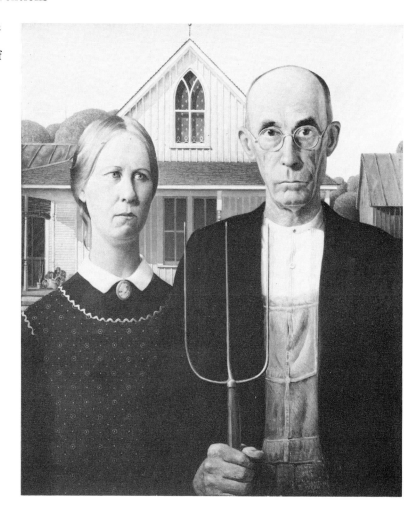

notion that somehow it is possible for pictures and reports to be produced which totally ignore the feelings and prejudices of the communicator: the 'I am a camera' heresy. A camera needs someone to press the shutter-release. No two people faced with the same scene would produce identical pictures: camera angle, timing and exposure will each affect the final result, so that photography can be as expressive of personal attitude as any medium, even without the intervention of darkroom skill.

Acceptance of the subjective nature of any medium has led many writers to turn the word 'realism' right round: a work may be considered realistic to the extent that it brings the audience in touch with the artist's 'reality'. To achieve this, it may have to break with any notion of naturalism and with conventions of presentation. A 'text of bliss' may in this sense be more realistic than a 'text of pleasure', even though the latter is a more accurate reflection of the audience's expectations. Munch's print *The Scream* excites a sense of the painter's state of mind more accurately than would a psychiatrist's report.

Fig. 5.9 Edvard Munch, *The Scream*. 1916. Courtesy of the Nasjonalgalleriet, Oslo/Newcastle Polytechnic Gallery Poster (1984–86) taken from painting.

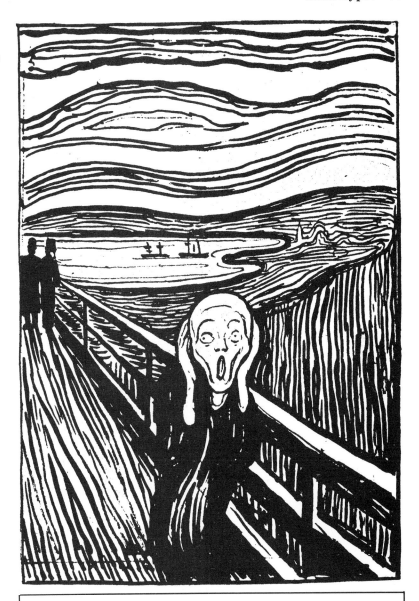

Stereotypes

In introducing our explanation of semiology (see above, p. 36–7), we pointed out that anything can serve as a sign – word, garment, gesture or colour. The mass media also use people as signs: for example, a burly, middle-aged male is likely to be given an unfavourable role. In Hollywood films of the 30s, black actors were usually asked to play comic and stupid cowards; women were generally the objects of male desire and domination, ineffective when not directed by a man – think of all those scenes where the hero fights the villain while his girl-friend looks on, terrified and helpless.

We refer to a sign as a stereotype when signifier and signified merge to reinforce in the audience a belief that the signifier necessarily embodies this concept – that women are always weak and unreliable, that black people are always foolish cowards. Such stereotyping will continue until the group so portrayed become powerful and indignant enough to demand more favourable treatment. Some groups are quite happy with their stereotype, of course – neither American doctors nor lawyers have seen fit to complain about their almost universal representation as wise, disinterested philanthropists. By contrast, the emergence of an effective black consciousness was quickly acknowledged by Hollywood: *Cat Ballou* gave to Nat 'King' Cole the first part which reflected the fact that many of the West's pioneers, cowboys and gamblers were black.

A degree of stereotyping is inevitable in any figurative medium. To communicate, you need a vocabulary of readily understood signs. Personality and attitude can be conveyed by emphasizing certain features. In Gainsborough's much-discussed portrait of Mr and Mrs Andrews, for example, the eyes are emphasized to draw attention to their sideways glance: the suspicious hostility which this signifies is every bit as conventional as the wealth implied by the fields in the background.

The effective communicator does not do away with signs, conventions or even stereotypes, but combines and manipulates them in original ways to achieve new ends. To say that a mass medium depends on the skilful manipulation of stereotypes is not a condemnation, but an acceptance of its methods and an indication of its possibilities. The medieval craftsmen who designed stained-glass windows for the great cathedrals of Europe knew this as much as the poster-designers of the twentieth century.

The construction of conventions

Corporate identity

Any organization, be it multi-national corporation, urban arts centre or government department, needs a clear sense of its identity and purpose, and needs to project this sense to its own staff, to the general public, and to other organizations with which it deals. Defining this sense is a task of management in which the expertise of public relations can be used, and it will be carried out by means of extensive interviews within the organization and

A *stereotype* is a portrayal of a person or a group in oversimplified and unquestioning terms. Thus, if doctors are always portrayed as perfectly efficient, humane and self-sacrificing, this ignores the reality that many of them suffer from ordinary human weaknesses.

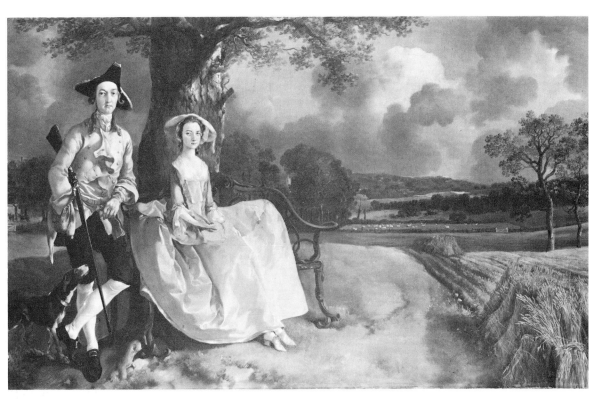

Fig. 5.10 Thomas Gainsborough, *Mr and Mrs Andrews, c.* 1750, canvas, 27½'' × 47''. Reproduced by courtesy of the Trustees of the National Gallery, London.

Bradninch Place

Gandy Street

Exeter EX4 3LS

Phone Exeter (0392) 219741

outside it. Unless the organization is completely new, two pictures will emerge: the way it is actually seen, and the way it would like to be seen. The next task is to change the former image so that it more closely resembles the latter. In doing this, a number of tools can be used, but one of the most important is the skill of the designer.

Let us consider two contrasting situations: a new organization which needs to make an impression on its local community, and a national company with many branches.

The Exeter and Devon Arts Centre was established after a long series of meetings and informal discussions between a number of interested groups. Eventually, a building was acquired and a director appointed. Her first task was to define the objectives of the new centre and obtain agreement to this definition from the different sponsoring bodies. These objectives were incorporated in the layout of the building, but also had to be communicated to potential users and to the general public. At this point, long before there was a programme of activities to advertise, she briefed a designer to produce a visual identity which would be imposed on everything emanating from the centre – posters, letters, tee-shirts and so on. The colour scheme and signs inside the building itself reflected the same style.

The house-style had to be 'un-datable, memorable and eye-catching'; it had to present a warm, friendly and approachable face in spite of the imposing late-Victorian style of the building. The centre was to be interested in a wide range of popular arts and

crafts, but with an eye to the potential uses of new technology in creating art and for arts education.

The illustration shows an example of the completed house-style. The colours are dark blue and bright orange-red (the logo uses the former for 'Exeter and Devon' and the latter for 'Arts Centre'). These colours were incorporated into the decor of the building, as well as into the centre's literature. The clean lines of the sans-serif typeface balance the calligraphic flourishes in the same way that old crafts and new technology were to find a home with this new organization.

In contrast to the localized design intention of the Exeter and Devon Arts Centre, it is interesting to look at the corporate image of a major industrial company. The Associated Portland Cement manufacturing company has adopted a blue circle as their identifying sign. A circle is, of course, one of the simplest and least confusing shapes. It does not represent in graphic form any process associated with the manufacture of cement. In isolation, there is no reason why we should associate it with this type of company. However, several years of use have ensured that the blue circle has now become memorably linked with the Portland company.

It would be wrong, however, to attribute the memorability of this sign to usage alone. All known precedents of symbol design indicate that a circle should be too 'pure' to be capable of annexation by one company. In other words, the circle has not so much been designed as selected by the designer, F.H.K. Henrion. He has of course been sensitive to the problems of applying the circle to notepaper, labels, vehicle livery, and so on. What still remains interesting is that the logo is simply a circle. Or is it? Look at this series of photographs taken to simulate a car-driver's view of the cement tanker lorry. Only in the first photograph, taken from a considerable distance behind the circle, does the logo appear to be a circle at all. As we get nearer, we can see that it

ceases to be seen as round. In fact, by any acceptable geometric definition, it is not a circle at all. It is probable that the memorability of the circle is due precisely to this shifting character.

A further tool available to the graphic designer in implementing a house style is the imposition of a standard grid, a basic pattern around which posters, leaflets and reports can be designed so as to convey a sense of unity. When this is used in combination with standard colours, typeface and logo, the common origin of the documents is emphasized.

Special purpose codes

Within the constraints imposed by a house style, the designer may be asked to develop a more explicit set of signs for particular purposes. This may range from colour-coding certain types of work or message to devising stylized images or signposts. At the Olympic Games, for example, signs have to be produced for each of the different sports, and the same sign will be used on programmes, tickets and direction signs. If each of these was produced independently, the result would not only be untidy but would produce confusion among visitors and competitors, who may not speak the host country's language or even know their alphabet. Directions must thus be motivated and quickly learned so that the link between sign and activity is direct and immediate. If that is not sufficiently demanding, the designer will probably also be asked to project the organizing committee's view of what makes these games different from previous Olympiads.

A visual code has the advantage over verbal messages that it is more quickly read and less subject to differences of language or reading-ability. Provided that allowance is made for cultural differences, and provided frequent opportunities are offered for learning the code, words should where possible give way to images.

Summary

Codes, systems of signs, can evolve over many years in response to the needs of a society or can be created as a response to short-term needs. The former type become practically invisible to the communities which use them, who cannot imagine any other way of dealing with reality. It is also probable that, in the course of time, the categories which they embody can come to influence the way that their users think. Artificial codes, such as those developed by the mass media in the twentieth century, can become so all-pervasive that they acquire similar influence to that of language and other basic systems of culture.

Where do we go from here?

Ernst Gombrich, in *Art and Illusion* (Phaidon, 1977), looks at visual codes from the viewpoint of the art historian rather than the semiotic theorist. Art rather than psychology is also the focus of *The Language of Clothes*, by Alison Lurie (Heinemann, 1982) who brings a perceptive novelist's eye to the subject, although she is inclined to assume that European and American conventions are universal, giving little or no consideration to the systems of other cultures. John Fiske and John Hartley's *Reading Television*

(Methuen, 1978), examines the conventions of this important medium; their insights (notably their chapter 'Bardic Television') provide some useful starting-points for the consideration of other media.

6 Symbol, Metaphor and Image

Although the link between sign and meaning is usually arbitrary, some signs acquire a power which seems more than accidental. Partly this can be explained by their connotations. To an American, the image of the Stars and Stripes calls up memories of the many previous occasions when it has been seen, and the emotions associated with it – pride, sense of belonging and sometimes anger or frustration. The potency of the image derives from these memories, which also explain why it is used on occasions requiring the most persuasive forces of national communication. Other signs use the connotations of a physical object to represent an abstract idea or emotion: since a storm is associated with violent destruction, it is often used to represent anger, which has the same effects.

Another group of signs have such international effectiveness that we see them as the reflection of universals of human psychology: the moon and stars as passionate solitude, a baby as innocent vulnerability, maggots in meat as moral corruption.

Some apparently universal signs, however, owe their widespread use to the international structures of mass communication: the cowboy, the astronaut and the heroin-addict are for most of us stereotypes for which our daily lives provide no equivalent experience. One mass-media image can only be compared with another.

The image: a memorable picture

Two photographers who stand side by side may take pictures whose values differ completely. There is a significant difference between the picture on the page and the picture in the brain: given the selective nature of our perceptual system, it is not to be expected that all optical stimuli will be treated equally. An *image* has been defined as *the result of endowing optical sensations with meaning*. The complexity of this process is indicated by studying Henri Cartier-Bresson's photographs. There is no denying their impact, but to define it is a difficult task. We would also part company with Cartier-Bresson's own analysis, which tended to

Fig. 6.1 Henri Cartier–Bresson, *London: Coronation 1937.* Courtesy Henri Cartier–Bresson.

focus on the formal elements of the photographs. These works are vividly memorable, and it would be tempting to assume that Cartier-Bresson's gifts for formal composition can explain this distinctiveness. To do so would be to reduce his famous 'decisive moment' to the choice of that fraction of a second when mass, line and texture can be arranged in a pleasing way on the final photograph. If this were true, it would not be enough to raise his work above any competently framed pictures, where composition is directed by an intuitive sense of design. Cartier-Bresson's images go beyond this: the best of them add to composition the reflex response to a moment of psychological insight. In painting,

the image is usually the result of bringing together elements of an underlying pattern which the viewer supplies. The intuitive leap of completion which takes place in response to an image is the source of its compulsive and satisfying fascination.

In this chapter, we shall consider some of the most common types of signification, the link between a signifier and the concept which it signifies. Some of these are transparent to rational analysis, like the process by which we learn to associate a red light with the need to stop. It is important at the outset to remember that, as with the image, the link may be partly or wholly obscured from our conscious minds. There remains a ghost in the machine of our orderly analysis; which does not, however, absolve us from the obligation to follow our intellects as far as they will take us.

Metaphor: matched connotations

Emotions, beliefs and concepts are inherently invisible: we may see the effects of anger or justice, but not the feeling or principle itself. In visual communication, as in language, we have learnt to infer the abstract from the concrete.

The advertisers of Mint-Cool had to find a visual equivalent for two physical sensations. The vulture on the tongue we consciously interpret as 'foul taste'; after another picture showing the product being used, the vulture is replaced by four doves in flight which signify 'peaceful and innocent pleasure'.

In *metaphors* such as this, an aspect of the object portrayed is thought to be inherently the same as an aspect of the idea signified. In our culture, after years of Western films, the vulture is associated with drought, death and decay. By embodying these, it can signify the tastes which they represent.

Magritte's image *The Rape* is a more complex metaphor. It combines the outline of a face with the torso of a nude woman to provide a striking visual equivalent for the metaphorical expression 'He undressed me with his eyes'. A literal equivalent for the statement would be such a statement as 'Many men are incapable of thinking about women in any except sexual terms'. As it stands, this is not a very persuasive statement: Magritte has a more direct access to the emotions through which we can be persuaded by offering us a paradoxical image which our imagination resolves.

Although such metaphor can often transcend the boundaries of language, it should not be assumed that it will have universal effect. Essentially it uses a process of matching connotations: those of the object with those of the signified idea. Through the international processes of the mass media and the trade in art-objects, of course, people in many countries have learnt some similar sets of connotations. The *Mona Lisa* is an instantly

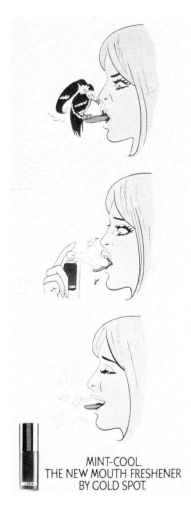

Fig. 6.2 Mint-Cool advertisement. Courtesy Ashe Labs.

MINT-COOL.
THE NEW MOUTH FRESHENER
BY GOLD SPOT.

Fig. 6.3 Rene Magritte, *The Rape (Le Viol)*, 1934, oil on canvas, 28¾″ × 21¼″. © ADAGP 1986/Menil Foundation Inc.

recognizable sign from Paris to Tokyo, and has similar connotations in both places. However, most objects acquire more local connotations.

Picasso's great painting *Guernica* (see p. 96), which commemorates an atrocity of the Spanish Civil War, uses a variety of means to convey his horror. The image is complex, and each element deserves separate analysis before one could contemplate an overall explanation of the painting's effect. Metaphor occurs in several places, for example in the arm clutching a broken sword at the

Metaphor is the use of a physical object to represent an abstract idea or emotion. It depends upon a more-or-less conventional link between the connotations of the object and those of the idea.

Fig. 6.4 The nave of Wells Cathedral, an example of Gothic architecture.

bottom of the picture. This is more than simply a sample of the carnage produced by the bombers; it reminds one of the defencelessness of the people who were attacked.

Architectural styles, particularly in religious buildings, have often been explained in metaphorical terms. The lightness of Gothic architecture, and the way in which its lines draw the eye upwards, have been held to signify the illumination of the soul when the mind is uplifted in prayer. The open, undivided space of a mosque is a metaphor for Islam's rejection of religious elites; within the main body of Islam, there is no priesthood, but only individual believers distinguished by piety or learning. Similarly, the mosque, like early Christian churches and Jewish synagogues, includes a separate area for women as a metaphor for the separate status of women.

Politicians and dreamers have also used architecture in a

Fig. 6.5 The mosque at Kufa, the shrine of Ali. Courtesy the Iraqi Cultural Institute.

deliberately metaphorical way, as when Albert Speer, Hitler's architect, designed vast buildings which dwarfed the human figure in the same way that the Reich sought to exclude any sense of the individual's autonomy or worth. Communes and experimenters with alternative lifestyles often embrace new types of dwelling to emphasize their need for flexibility and freedom: the wigwam, dome and 'bender' tent are just three of the best known.

Metonym: a part for the whole

Another way of indicating an abstract concept is by showing some of its effects. Thus, unemployment is not something which one can portray directly; but a photograph of a person whose miserable idleness is evident in posture, facial expression and dress can signify the economic condition which produced it, as can the notorious queue of people which was used a few years ago in a British general election poster.

In *Guernica*, the heads of screaming men and women represent the many people whose suffering inspired the painting. Their expressions are the product of the pain they endured: this

Fig. 6.6 Pablo Picasso, *Guernica*, 1937. © DACS 1985.

connection is *metonymy*. As individuals, they also stand for the Basque nation whose embattled state was another of the painter's concerns.

If we wish to signify a complex entity such as the United Nations, we can isolate a building, a person or a group to stand for it: the headquarters in New York, the Secretary General, or delegates in a range of national costumes. When Gainsborough included a field in the background of his portrait of Mr and Mrs Andrews, it was not the whole of their wealth, but was a sign which could be read as a sample of their vaster and more diverse power. A famine is an overpowering and unimaginable human disaster; a small, withered hand held in a larger, plump one can convey effectively the nature of the problem and imply a solution in one image.

Just before the election in 1945 which removed Churchill, the British war-leader, from office, a newspaper printed a photograph of a hand holding a Churchillian cigar and resting on a gun: even without the caption, 'Whose finger on the trigger?' it was a powerful metonym for the bellicose nature which was being attributed to the Prime Minister.

You cannot make a picture of the feeling 'comfort'; you can, however, make a list of the objects which produce the sensation – fire, slippers, armchair, and so on. By doing this you are using metonymy in a way which we associate with television advertising, but which is almost as old as painting itself. Tears and smiles are used as attributes of the emotions which provoked

Metonymy The use of an attribute of something rather than the thing itself to convey its meaning: an effect to represent the cause, or an object to represent the person or organization which uses it.

them; Pharaoh's armies are painted on the walls of his tomb to remind us of the power through which he controlled them. Similarly, many caricatures include metonyms: the destructive energies of a politician can be indicated by building into the image of his or her figure the instruments through which this destructiveness finds an outlet.

The power of a sign can be increased by using it in two ways – for example, as a metaphor and as a metonym. When a great general is commemorated in an equestrian statue, his horse and weapons are metonyms for the forces which he controlled and metaphors for his courage and determination.

Icons: supercharged signs

At the heart of any culture are a number of heavily used signs which acquire particularly rich connotations and which accordingly convey powerfully stable meanings. Such signs may be referred to as *icons*, after the religious pictures of Orthodox Christianity, and which are popularly felt to embody the power of what they portray.

When Rauschenberg uses a picture of an astronaut and one of President Kennedy, his American viewers bring to the print a wealth of experience and emotion. The newly dead politician had in his life expressed the ideals and ambitions with which many Americans also endowed the space project. Kennedy himself used the phrase 'new frontiers' to describe the spirit which he wished to encourage in American society. In so doing, he was asking to be identified with the figure of the pioneer whose covered wagon had tamed the wild west. This image is an important key to the American imagination. It is an icon which, in spite of superficial changes, continues to produce the same popular response. For many, space research and the astronaut are among its current embodiments, but even within the counter-culture of radical movements one can detect the continuing appeal of the person who strikes out an independent but difficult path away from the safe but oppressive ancestral home.

A British politician photographed before a hearth in which burns a coal fire, and a German politician at the Berlin wall, know that although each member of the audience may have unusual personal connotations for that sign, these will be swamped by the collective connotations of the community. The hearth, traditionally the centre of family life in Britain as in other

Icon A sign which, through frequent repetition, gains a central position in the communication systems of a culture and thereby acquires rich and relatively stable connotations.

countries, has connotations of security, companionship and acceptance. It can thus be used as a metaphor for all these aspects of a party's policies; its emotional appeal is almost irresistible.

Since its construction more than 25 years ago, the West's media have used the Berlin wall as a metonym for the division of Germany into two states, and a metaphor for the defensive, closed minds which Western governments have seen in the East German leaders. Again, the image is effective because of the emotions which have been transferred to it. The most effective of the shared signs of a culture can usually be traced back to a relatively small set of types, which reappear in different guises appropriate to the times. Successful persuasion in the mass media often depends upon appropriating to one's own use the icons of one's culture, as Gandhi appropriated the spinning wheel and Kennedy the early pioneers. The crudest of these icons is the national flag; most are transformed in subtler ways, as when the preacher in the pulpit becomes the teacher, the soapbox orator and the commentator on a television documentary. The connotations which became attached to the preacher over hundreds of years have been handed on to other people who have assumed part of his function in society.

Symbols: signs of the subconscious

When we look at the bull at the top left-hand corner of *Guernica*, we are faced with a sign whose meanings are complex: some of these meanings are open to unarguable rational analysis, but when we have finished such a dissection we are left with a large component of its force which remains unexplained. In Spanish culture, the bull is an icon which can be traced through a variety of forms of representation. In this bull, however, there is a disturbing and nightmarish quality. The misalignment of the eyes conveys a sense of unease analogous to that caused by a disturbance of the moral order; on such a powerful beast, the effect is heightened. The brooding presence of the bull seems to signify something at a level which our conscious minds cannot grasp.

One of the most important concepts in twentieth-century psychology has been Freud's development of a theory of the subconscious: that, in addition to those mental activities of which we are aware, there is another, possibly larger, mental world whose existence is only rarely made apparent. In our dreams and fantasies, and on occasions of critical emotional stress, we may be brought face to face with aspects of ourselves previously unknown to us and often distasteful to us.

This is not to say that their origin is in any sense supernatural, but rather that the forces which kept these thoughts and feelings buried in our subconcious are not available to straightforward self-analysis. Freud and his successors claim that we drive into our

subconscious those feelings of which our conscious minds have taught us to be ashamed, or which are so painful that they cannot be faced. Inevitably, psychologists describing such hidden processes will differ about their precise nature, but it is no longer possible to write about the life of the emotions without at least attempting to define the contents of the subconscious mind.

Freud felt that the mainspring of the self was sexual energy, transformed by the conscious mind into a variety of more acceptable forces – creativity, loyalty, and so on. This being so, the primary meaning of dreams and other symbolic expressions of the subconscious should be seen in sexual terms. If we dream repeatedly of drowning, or if we have a persistent fear of water, then we may do so because for our subconscious water has come to symbolize the sexuality which is the real source of our fear.

Jung and many other successors of Freud dislike such simple notions of the subconscious, and emphasize that each person uses *symbols* in an individual manner, reflecting a view of the subconscious which included far more than solely sexual preoccupations. For Jung, a symbol was any sign which implied more than its obvious meaning. Its occurence in a dream or in a myth could often be linked to one of the great themes of human existence – birth, death, marriage, fear, disease, hope. Furthermore, Jung's interest in the cultures of mankind led him to notice that similar symbols could be found in widely separated communities. He refused to accept that such persistent imagery could be explained simply in sexual terms.

Animals play an important part in dreams, legends and the irrational fears of the mentally disturbed. Jung explained this by saying that, subconsciously, each animal represents an aspect of the self and more specifically signifies the instinctual part of one's nature. In an image of a mounted horseman, for example, the horse often represents the human will or consciousness. Accordingly, its appearance in a dream, a myth, a phobia or a painting immediately attracts our attention: Picasso's dying horse could be interpreted as the death of the individual or as the end of human individuality.

In our mechanical age, the persistent use by film-makers of the car-driver suggests that this is as powerful a symbol as that of the horse-rider; it may indeed be a modern embodiment of the same symbol.

Any presentation which excites a strong human response would be analysed by Jung in the same way as a dream would be interpreted. The excitement and horror of, say, a Steven Spielberg film are indications that the director and scriptwriter have incorporated a number of stock human situations or motifs. These underlying universals of human expression Jung labelled

Symbol A sign which implies more than its obvious and intended meaning, and which derives its force from the subconscious.

archetypes, or archaic remnants from the dawn of human consciousness. The descent of the hero into a vault or cave to rescue a precious object guarded by poisonous snakes is a theme which can be found in contexts ranging from ancient myth to modern film. The reason for its compulsive fascination is that it is a conscious manifestation of a universal human experience which is not available to mechanical interpretation but only to the less rational processes of insight.

Archetypes are most often single universal symbols – the wise old man, the trickster, the man-beast. However, Jung was also interested in the regularities which he observed in the ways they were combined in the legends and dreams of different societies, so that he was inclined to treat these patterns also as aspects of archetype.

Myth and ideology

In his essay on Myth in Education, the poet Ted Hughes has pointed out that the figure of Saint George, the dragon-slayer, is one of the most potent symbols of Christianity. In Northern European stories and legends at least, the hero who destroys evil has been a recurrent theme since before the time of Beowulf. Hughes suggests that its recurrent use has important implications for society: in symbolic terms, 'it sets up as an ideal pattern for any dealing with unpleasant or irrational experience, the complete suppression of the terror.' He claims that this is an extremely dangerous formula for a society to use in forming the imaginations of its young people. The suppression of fear and the refusal to admit one's shame can often be a precursor to a mental or emotional crisis, for which the only cure is an acceptance that the dark side of one's nature exists, even if one refuses to allow it dominance.

It is difficult to understand the history or culture of a people without taking account of the stories which have the most powerful hold over their imaginations. The Muslims of Iran, for example, venerate the Imams Ali and Hussein, and in particular recall Hussein's last stand against their religious enemies. In this battle, without hope of victory but certain of the rightness of their cause, Hussein and a small band of followers refused to flee but stood and perished. Such a story, adapted and retold from infancy, cannot fail to affect the hearer's imagination and ideals.

Myth is the use by a society of signs and symbols which explain and transmit central beliefs. Every community has its own version of the Creation, or of how its society was founded. The complex evolution of a society like Ireland or Greece, and the reasons for its values and customs, are presented as a series of tales which are

repeated and handed down from one generation to the next to ensure the perpetuation of its way of life.

The Western film is such a myth in twentieth-century America. The same few basic signs are repeated in essentially the same sequence:

Strange man arrives, seeking someone
Bad men threaten him
Woman pleads with him to abandon his quest
Hero persists, killing his enemy through individual skill and courage

The persistence of this formula in the American film industry, and its similarity to the patterns of other genres, such as the James Bond film, reflect the strength in American society of the view that individuals are more important than the social structures of which they form a part. Such a pattern would be less popular in a regime which aimed to stress collective or impersonal forces in a society, such as those of class or ethnic group.

Clearly such an explanation is incomplete, and ignores the potency of the symbols used. The Western is memorable, at least in part, because of the power of the archetypal symbols which it embodies. However, the repetitive patterns of a genre which are revealed by structuralist analysis only become important when linked in this way to more general habits of a society.

The standard practices of the mass media have been repeatedly analysed in recent years to highlight this political dimension. In Marxist terms, it is claimed that the ruling group in a society justifies its position through 'ruling ideas' – individualism, for example, in the Western. *Ideology* is, in one sense of the word, the process through which these ideas are disseminated.

The individualism of the Western film has its counterpart in the way the media use the icon of the artist: isolated, wracked by a daemon, rendered impossibly sensitive by the burden of genius, and sacrificing all for Art. Such portrayals also use a fairly crude definition of success; but the media have developed even cruder measures in their other representations. Almost any kind of performance is presented in terms of marks, winners and losers: dance contests, sport ('goal of the month'), knowledge (quizzes), music ('Top of the Pops'), beauty and so on. The repetition of this pattern, it has been claimed, moulds the consciousness of the viewer towards a competitive, individualistic view of society.

To quote Ted Hughes again, 'When we tell a story to a child, to some extent we have his future in our hands insofar as we have hold of his imagination.' The same is true when we paint a picture: the images we create from our vocabulary of signs and symbols help to perpetuate the myths by which we live. What is more, we can only learn to read new images through the patterns which we have already internalized, and which form an unquestioned basis

for our thought. A totally innovative act of communication would be unintelligible; as Gombrich wrote in *Art and Illusion*: 'Language grows by introducing new words, but a language consisting only of new words and a new syntax would be indistinguishable from gibberish.'

Summary

The persistence and effectiveness of certain signs may often be explained by the richness of connotation with which they are associated. They may also be explained by the nature of the human mind, and in universal features of the way the subconscious mind handles fundamental human emotions and conflicts. Societies also favour certain types of representation as ways of transmitting the cultural values of the group.

Where do we go from here?

The photographs of Henri Cartier-Bresson should be studied carefully to identify the concept of 'image': many of them make banal subject-matter memorable, sometimes through obvious skill in composition, but usually for less easily defined reasons.

Metaphor and a number of other rhetorical devices are analysed in the later chapters of Gillian Dyer's *Advertising as Communication* (Methuen, 1982). The best starting-point for the study of symbols is *Man and his Symbols* (Pan, 1978), edited by Jung just before his death, and which includes a chapter on symbolism in art. There are many exhaustive discussions on ideology in the media; two collections of essays which would help to open up the subject are *Culture, Society and the Media* (Methuen, 1982), edited by Michael Gurevitch, Tony Bennett, James Curran and Janet Woollacott (particularly the essays by Tony Bennett and by Stuart Hall) and *Popular Culture: Past and Present*, edited by Bernard Waites, Tony Bennett and Graham Martin (Croom Helm, 1981).

7 Functions and Uses of Communication

Our intentions in sending messages are not always the same as the purposes which they finally serve. What is more, the function of an image can change over time. Consider the photograph of a footballer which a boy buys from a local newsagent. The photograph is produced in response to the football club's need for publicity to ensure its financial survival. For the boy, it is a factual reminder of the appearance of an admired sportsman; but it is also more than this. It raises his status within his circle of friends, and may indeed become an object of trade; it stimulates his imagination with dreams of heroic goals scored or saved. In later years, the picture is a reminder of the pleasures and values of a distant childhood. The photographer and the football club produce a message; they can influence, but not determine, its eventual uses and functions.

Needs and attitudes

In an earlier chapter, we referred to the different meanings which may be offered for a message by the sender and the various receivers. A similar problem arises from the ambiguity of the term *function*, which embraces both the purpose of the sender and the response of the receiver. This pragmatic level of communication analysis deals with the problem of how we change behaviour, and how attitudes and needs affect this change.

The question of function cannot be ducked. A photograph is taken, or a canvas painted, in order to achieve an end, however vaguely that end is perceived. You may sketch a person in order to remind yourself or persuade others of your skill, or perhaps to give pleasure to the person whose likeness you try to capture; you may even be drawing for the pleasure of the act itself. Nevertheless, the aim is there. Understanding your aim may improve your chances of achieving it. Realizing that you have a number of separate intended functions can also be helpful.

The impact of a picture is also modified by the state of mind of the person who comes to it: what that person is looking for, the attitudes they bring to this subject, and so on, will change the first

and possibly subsequent impression they receive of the subject. First impressions count for a great deal. One element in the composition will immediately strike the viewer; but the prominent feature of a visual image changes according to that viewer's actual needs. A photograph of an attractive young woman eating caviar on a sunny beach will affect the viewer differently according to whether that viewer is, for example, hungry, cold or male.

Differences between the purpose of an image and its use will depend, therefore, on the receiver's attitudes and needs. Needs, like moods, are changeable: the events of the next two hours may cause needs which now seem important to be replaced by others. An attitude, by contrast, is a consistent way of responding to similar situations and stimuli, like the editor of a famous women's weekly who was said always to choose cover photographs which resembled herself.

If you are working on an advertisement, the needs and attitudes of your audience will be predicted by a marketing specialist. A well established product will have a regular market, whose ages, interests, beliefs and so on can be studied by market researchers, who may then identify a gap which is not being reached. Part of this identification will concern attitudes – to this product, to rival products, to existing advertising. This is not by any means a simple process: consider the complex attitudes which must be faced by the organizers of campaigns to reduce drunken driving, stop children from smoking, increase contributions to famine relief or to change the most deeply-rooted habit of all – the choice of a daily newspaper.

More often, awareness of your audience's attitudes and needs will have to come from personal experience or empathy. If you are a jeweller, do your customers expect a display of precious materials or of skill? If you are designing the set for a play, does the audience buy tickets for lavish opulence, elaborate machinery or pared-down simplicity so that the words and relationships of the play can be enjoyed with a minimum of distraction? There is no fixed answer; each occasion brings its own constraints.

Needs and attitudes change the meanings of signs: How we classify what we see depends on our state of mind just as much as on the culture within which we operate. Our very language teaches us to classify objects in particular ways. English speakers, by using the words 'rat' and 'mouse', distinguish carefully between animals which other cultures put together as 'big rat' and 'little rat'. Experience also plays a part in our classifications. Like many other people, you may have only two categories of tree: those which do, and those which do not, lose their leaves in winter. A forester will have many ways of classifying them, some of which cut across the question of leaf-shedding.

Individual attitudes can also be responsible for the creation of categories which may be a complete jumble to another person: consider the categories 'things I like', 'things I fear', 'people I

respect'. One person's meat is another's poison. When you include something in a composition, your audience may categorize it differently from the way you expect. You may include a piglet in a picture to represent 'pretty, friendly small animal': to a Jew or a Muslim, it comes in the category 'dirty, disgusting and polluting creature': in this case, the attitude comes from the culture, but in other cases it is the product of personal experience.

Although attitudes are relatively stable, and needs variable, it is possible to detect consistent patterns of need. There are common types of need, and certain categories of need regularly take priority over others. Events of the next few hours may satisfy one immediate need, revealing another; my need for companionship may be satisfied by an agreeable conversation with a friend, but leaving me conscious of a need for exercise, for food, or for self-expression.

Maslow (1970), the humanistic psychologist, felt it was possible to distinguish five levels of human need:

(a) physiological needs: warmth, food, water, shelter, sex.
(b) security: freedom from danger and deprivation.
(c) social needs: companionship, acceptance, love.
(d) esteem: self-respect and the recognition by others of your importance.
(e) self-actualization: the creative and expressive achievements through which one reaches a sense of personal fulfilment.

These needs form a hierarchy: if the first level of need has not been satisfied, one is unlikely to feel the pressure of higher-level needs. The person who is tormented by fears of unemployment (a security need) is more concerned with the need to hold onto the job than with the admiration of work-mates, and self-actualization only becomes an important problem to one who basks confidently in the respect and companionship of colleagues, family and friends.

Both attitudes and needs can be described in this hierarchical manner. If I wish to change one of your attitudes, then I can normally only do so by making you feel that it clashes with another which is even more important to you – an attitude which reflects a more fundamental need.

If someone is to 'buy' the visual message which you produce (to linger over it, pin it over their desk, be persuaded by its ideas) then they must feel that it answers some kind of need in them. Advertisements are often described as 'creating needs', but this is a rather clumsy shorthand for what is really happening. The needs exist independently of any salesmanship: what the advertiser can offer is a new, quick, cheap or convenient way of realizing them. A middle-aged couple have the security needs of anyone else: an insurance company can threaten them with poverty in their declining years if they fail to put a large slice of their present income into insurance. A young home-maker needs to feel the esteem of neighbours and friends: detergent manufacturers can

offer the prestige of sparkling white shirts, and paint-manufacturers the pride of sparkling white window-frames. A teenager with the normal desire for acceptance and companionship can be offered a face-cream which will remove spots and guarantee social success. In each case, the need is there before ever the advertisement is seen.

Fine artists may regard this concern with the audience as crass by comparison with the subtlety of their own role, but they would do well to remember that they, in a different manner perhaps, are also concerned with audience needs. Customers who pay for their products or buy tickets for their exhibitions do so in the expectation of some satisfaction from the transaction. This may simply be what in the last chapter we called 'the pleasure of the text': visitors are confronted with what is reassuringly familiar, and their attendance may be a celebration of security in that, although the canvases may change, the essential experience does not. The entrance ticket may help to satisfy social needs, asserting your membership of the group which values this kind of experience. A slightly less reputable reward is that offered to the viewer's self-esteem: 'I am a person of sufficiently exquisite sensibility to perceive the value of these works.' In Maslow's terms, the highest reward is to the viewer who is offered an insight through which self-fulfilment becomes possible.

What is true of the gallery-visitor is true of the 'consumers' of any other visual image: whether you require their attention or their money, you have to offer something in return. If the experience offers nothing by way of reward, it deserves little success. You may despise your audience, but do not expect them to pay for your scorn.

Uses and gratifications

Communication theories have increasingly emphasized the role of the receiver; from Shannon and Weaver's largely passive character, the receiver has become an equal partner in establishing meaning. The logical end of this trend has been a body of research, largely concerned with the mass media, which places the receiver at the front of the transaction. Earlier approaches concentrated on analysing the output, motives and attitudes of mass-media organizations; now we have research which endows the receiver with the initiative to choose the messages which will deliver the satisfactions needed. The viewer of a television programme and the buyer of a postcard are no longer seen simply as pawns manipulated by the producer, but as active agents seeking a product which will supply a need.

Katz, Gurevitch and Hass divide these uses into two types, personal and social:

(a) *Personal*

 (i) Understanding the self. By studying one's reactions to a story or picture, for example, one can explore the difference between what is portrayed and one's own experience and emotions.

 (ii) Enjoyment. Companionship, amusement, stimulation.

 (iii) Escapism. The principal gratification of many media products is to 'take us out of ourselves'. This process is similar to that described in psychology and literary criticism as catharsis, in which painful or violent feelings are purged through vicarious experience. Escapism, however, is usually considered in simpler terms, since it temporarily relieves the mind of preoccupations but does not fundamentally alter our attitudes or sympathies.

(b) *Social*

 (i) Knowledge about the world. Even an escapist adventure story may include information about ways of life beyond the experience of the viewer; similarly, social historians comb art-galleries and churches for illustrations of ancient practices. What an audience retains as 'knowledge' is of course beyond the control of the image-maker and may include fictional or imaginative elements.

 (ii) Self-confidence and self-esteem. What you see may reinforce your confidence in your attitudes and values.

 (iii) Connections with family and friends. The shared experience of looking at a film, photograph or painting can itself strengthen personal ties or else be used as material for the conversations upon which those ties depend.

These uses are not isolated from each other: one message often satisfies several needs. The poster on your bedroom wall may help you to fix your own identity and values, while at the same time offering aesthetic enjoyment, information and an opportunity for other members of the household to be aware of your tastes and interests.

Furthermore, the content or purpose of a message and the use to which it is finally put may have little or no connection with each other. The sophisticated students who watch an ineptly made horror film may treat it as a comedy; in the same way, a photograph presented as a record of information may be preserved as a sign of one's roots.

Jakobson's model of functions

So far in this chapter, we have considered two models of function which concentrate on the need which a message meets in the receiver. An alternative approach looks at the circumstances in which the act of communication takes place, and treats function as the feature of those circumstances to which the message is most strongly linked. Clearly, there are few messages which fulfil only one, clearly limited function: the human animal is too complex in its social and psychological operations for such a simple analysis. However, it is usually possible to agree that for sender or receiver the message has one main focus, and most discussions of communicative effect are based on this assumption.

Jakobson's (1960) starting point in developing his approach was to outline a model which could summarize the essential elements in an act of communication:

Fig. 7.2 Jakobson's model of functions.

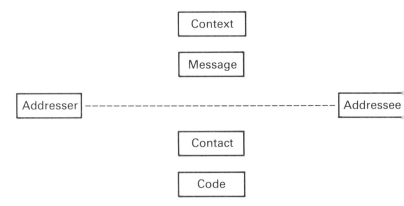

The two parties to the transaction, addresser and addressee, are linked by context, contact and code. The *context* is the situation which gives rise to the transaction; the *contact* is the physical and psychological connection between the parties (channels or media); the *code* is the shared system of signs.

A bowling team chatting over a drink after a game share all of these elements: the code is the language which they use, the context is their shared enjoyment of the game and team-membership, and the contact is the location of their discussion.

In addressing yourself to the analysis of a particular transaction, you must start by identifying all of these six elements; you can then consider a single move or message within the transaction, when it should be possible to link its principal function to one or other of these features. You can then classify a message according to the feature on which it is principally focused.

Emotive messages are those which chiefly serve as a vehicle for self-expression on the part of the addresser: they are a form of release rather than an attempt to influence others. The cheering

supporter lost in a football crowd, the secret diarist with a horror of publication, the sufferer who uses paint and canvas as a means of coping with emotional stress – all are aiming at emotive ends.

Conative messages, by contrast, seek to produce an effect in the addressee: obedience, affection or amusement, for example. Much religious painting comes into this classification, as do many public notices and all advertisements.

Speech often draws the attention of the addressee to the context, that is, the circumstances in which the transaction takes place. It is thus *referential*: a news photograph may simply record an accident or a wedding, and a diagram may simply encapsulate information which I possess and you need. Of course, each of these examples may be used for other purposes too: the picture of a wreck may elicit our sympathy, and the diagram may contain my instructions to you. The total circumstances of the interchange will need to be examined afresh on each occasion.

Human communication is unusual in that so much of it concerns the very act of communicating: 'Why are you using that tone of voice?' 'Here I am using the word in the sense of . . .'. 'Your use of the palette-knife gives a feeling of . . .'. *Metalingual* messages are those which offer a commentary or gloss on the code itself which is being used.

Phatic communication serves mainly to keep open the channel, to reassure the parties that the contact is being maintained. Chatting about the weather, saying 'uhuh' while listening to your friend on the telephone, sending a postcard while on holiday ('Having a wonderful time. Wish you were here.') are important rituals without which our social relationships would be impoverished. They often appear to convey information, but this is mainly a façade which permits the real end to be achieved. The recipient of the card is less interested in the information which it carries than in the fact that it was sent.

There remains an important type of communication for which the focus of the sender is on the message itself rather than any outside reference or effect. The *poetic* function is absorbed in the fascination of the structure and texture of the signs themselves (which is not to say that all poetry is limited to this function; this is a limited use of the word 'poetic' rather than the loose sense in which it is used in ordinary speech). A designer will often add something to a layout or structure which cannot be explained solely in pragmatic or even expressive terms, but simply because 'it feels better that way': this is the poetic element.

The 'poetic' element, in this sense, is far more than simply the intuitive summary of past experience which we might call 'a good eye' or 'visual sensitivity'. It means that, on this occasion, the communicator is relishing the pleasure of using the medium, and is playing with its rules and potential. A child babbling half-nonsensically in the cot while settling for sleep is using language with a poetic function. A computer programmer who alters a

perfectly adequate program to make it more 'elegant' may do so out of professional pride, but may also do so (losing hours of sleep in the process) because of the inherent pleasure of using the system in an interesting way: this, too, would be poetic. Most fine art is produced with this intention: to explore and relish the possibilities of the medium.

We can now present these six types of function in diagrammatic form to show how they relate to the model of communication which Jakobson used as his starting point:

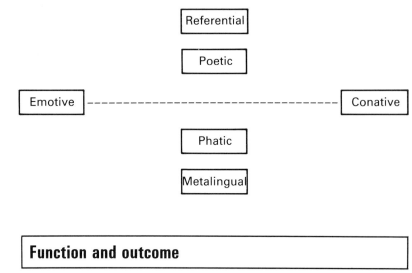

Function and outcome

The outcome of a message is dependent upon three factors: the intention of the addresser, the content, and the needs of the addressee. For this reason, and because none of these factors lends itself to definitive analysis, results will always be impossible to predict with absolute confidence; however, with experience you may be able to reduce the range of uncertainty.

Following a classification used by Ball-Robeach and De Fleur, we may sort the outcomes we wish to produce or observe under three headings: cognitive, affective and behavioural. *Cognitive outcomes* are those which relate to the information or knowledge available to the addressee; *affective outcomes* are changes in emotional state; *behavioural outcomes* are actions produced as a result of the communication.

Consider a charity which is planning its autumn fund-raising drive for famine relief. The posters which it is to use have a clear behavioural objective: to induce the passer-by to post a cheque as soon as possible. This action may be produced by an affective outcome, that is, a change in the emotional state of the viewer. It may be possible to address the emotions direct, through an awareness of public attitudes to the charity and knowledge of common emotional needs. More often, however, it will be

necessary to build on an initial cognitive effect: by conveying a quantity of factual information, the advertisement presents an apparent contradiction or challenge which has an affective or emotional element.

The cognitive or factual element may be presented as the core of an appeal, but this does not mean that it was uppermost in the minds of those who first devised it. A successful campaign for cancer research was built around a poster which listed 20 success stories (all true) which had come from recent discoveries about the disease. However, the agency which produced the poster knew that the emotional appeal of backing a winner was the strength of their campaign, and that they had to overcome an emotional resistance caused by the feeling that the charity, however important, lacked the glamour of success. The first draft of the advertisement was drawn up without any information about which causes they could highlight (the text was filled in at random from a Latin text-book: a common and unexceptionable way of testing the visual impact of a typographical idea). It could safely be assumed that relevant cases would later be found. The emotional appeal depended for its success on the existence of a body of supporting facts; the behavioural outcome (a marked increase in donations) was produced by success at the affective level.

This example may suggest that cognitive changes are the foundation on which other outcomes may be built, but the real relationship is more complex than this. The essential point is that however sharply you may wish to define your outcome, it will rarely be possible to focus solely on that single factor. Indeed, the main reason for employing skilled designers is often this precise point: the effectiveness of a message with a cognitive aim may be decided by emotional factors which in turn can be influenced by the layout or presentation of the message. Studies of the use of computer games as educational tools have revealed that presentation can have a marked effect on the learning brought about by a program. For instance, inclusion of an aggressive element (such as an arrow which popped a balloon when a correct answer was given) decreased the motivation of the girls, while increasing that of the boys. The careful use of typography, too, can change the attitude of readers to what they are reading, quite apart from its effects on readability.

Design as a holistic process

In an earlier chapter, we stressed that any element in a message could prove to be decisive or salient, depending on the expectations of the receiver, the medium or the circumstances in which the message is received. We also indicated that any element

in a message could change its meaning when used in a novel combination with other signs or elements. This is a well known process used in innovation and discovery in the arts.

Both in its forms of expression and in the uses to which it is put, we should regard design as a *holistic* process, that is, one in which the whole is more than the sum of its parts. For this reason, the most fruitful approach to a design task is one based on Osgood and Schramm's model described in Chapter 2, where sender and receiver are linked in a dialogue rather than as controller and pawn. Sketches and drafts should be subjected to trials with members of the potential audience, and modifications incorporated on the basis of their needs and responses. This is particularly important in all fields of applied design – graphics, fashion, packaging, etc.

Of the channels through which we can choose to send our messages, the visual is the strongest. This is partly because the parts of the brain which handle visual impressions are larger than those dealing with, for example, hearing; but it is also because we can attend to several visual messages simultaneously. This capacity, which is called *parallel processing*, enables us to take in the background in which a scene is being played while at the same time following the actions in the foreground. Speech, by contrast, depends on *serial processing*: we hear one word at a time and process it before proceeding to the next item. This means that complex concepts have to be absorbed in segments if they are communicated through the traditional medium of the word, while visual media permit several dimensions to be presented simultaneously. When word and image are used in combination, the resulting medium is even richer and more powerful. An audio-visual presentation is one of the most effective ways of communicating a complex concept; by contrast, the printed sheet has the sole advantage (so far) that it is more accessible.

Given the relative weakness of the printed and spoken word when compared to more complex visual channels, it is unfortunate that most educational systems give such a pre-eminence to books and talk. If we wish to foster in children the ability to think originally and creatively, we need to emphasize those media which encourage parallel processing. Problem-solving is rarely successful when approached in a purely serial, piecemeal fashion: solutions are more often the product of an ability to hold in the mind simultaneously several dimensions of a question, like a designer who has to think at the same time of purpose, use, materials, technology and financial constraints. To train such people to restrict themselves to serial channels of expression is to limit the potential of their thought. However, those subjects which encourage parallel processing (music, drama, art and design) are precisely those which are the most vulnerable parts of the school budget and timetable.

James Britton (1970) noticed an important function of language

which he called 'expressive': the use of language to explore new ideas and feelings, to produce 'tentative first drafts of new ideas'. He pointed out that it is often lacking in the formal completeness of less relaxed language, and is only produced in situations of intimate confidence. Most of us will recognize this from our own experience: we seek out trusted friends who will not quibble about detail while we talk out a problem, and in the very act of explaining the problem we become aware of the solution. Given the usefulness of this function of language, we need to foster an equivalent faculty which, following Britton, we might call 'expressive drawing'.

By training more people to use as wide a range of visual codes, materials and media as possible, we can both develop their ability to express complex ideas and feelings, and encourage them to respond with a critical sensitivity to the many messages they receive each day. Society is built on communication. One of the greatest services we can offer a person, whether as citizen, consumer or friend, is to extend the range and complexity of the communication they can handle.

Summary

Fundamentally, there is a limited range of human needs, although those felt by the individual to be most pressing will vary from one day to the next. In order to change attitudes, or to gain acceptance for a new idea, the communicator must use the needs of the recipient. How this person will in fact use the message is to some extent unpredictable. Any element in the design of a message may prove to be crucial; this is particularly the case with visual media, which are both more powerful than other media and more capable of handling complex relationships of ideas.

Where do we go from here?

Obviously, the first place to start is your own experience: look at the pictures which you keep, or which your friends keep (wedding photographs, pinups, holiday snaps, posters, diagrams) and try to identify the aims of producer and collector: how well do they relate to Maslow's or Jakobson's theories? Can you supply images which for you fulfil each of Katz, Gurevitch and Hass's uses and gratifications?

There are few books which apply these theories to visual communication – most of the work deals with the mass media in general. But read the essay by McQuail *et al.* in D. McQuail's *Sociology of Mass Communications* (Penguin, 1972).

8 Insights and Applications

The list of theories of communication which we have explored is neither complete nor a magic formula the learning of which is sufficient to transform a beginner into a sophisticated practitioner. The mediocre graphic designer will not suddenly become the star of the agency, nor will indifferent painters suddenly find a clutch of prestigious galleries vying with each other to exhibit their work. Our claim is important, but less ambitious than this: that the principles of communication will significantly contribute to successful practice when they are understood and assimilated into the visual artist's working practice.

Shannon and Weaver: the 'bull's-eye' model

The simplest explanation of the communication process is one which regards the sender as holding the initiative, like a drill-sergeant on the parade-ground shouting at recruits. He ignores any cultural or psychological differences between the members of his audience; his sole concern is that the command 'Present Arms!' is followed by the appropriate action. He has previously taught the code of commands; his only means of improving the quality of the transaction is to shout more loudly.

The application of this model is fairly limited precisely because of the scarcity of contexts where the recipient is so passive. Even in the arts, or in the mass media, where sender and recipient are sharply separated, the code itself is subject to alteration through audience effects or through the sender's perceptions of the receiver. The drill sergeant, by contrast, has had total control over the preparation of the audience to respond to just this command, and has narrowly defined and limited the acceptable range of response.

Shannon and Weaver's model also introduced a problem which has continued in communication theory: the use of everyday words in a special or technical sense – the problem of jargon. As a result, it is sometimes difficult to think of 'noise' in any but the auditory sense. The term emerged from Shannon and Weaver's work on the

analysis of radio and telephone communications, when crackle and gurgle was a constant factor in early voice transmission, and noise frequently overwhelmed the message to the extent that only the noise could be heard or remembered. In this sense, it became such a useful term that psychologists borrowed and adapted it to their own jargon.

A schoolteacher dressing down a student for some misdemeanour when the teacher's chair collapses; an attractive person talking to another with a smudge on the nose. Both are examples of 'noise', in this broader sense; in both cases we have difficulty in dismissing the noise and listening to the message. Indeed, it is possible to claim that the allocation of the labels 'message' and 'noise' is to a certain extent arbitrary; for a bored pupil, the collapse of a dignified teacher may well be more significant than the reproof which was being administered.

In the days before the women's movement made men more sensitive to the implications of such gestures, the army weapons instructor frequently included, as if by accident, the occasional pin-up in a slide presentation, on the theory that the men would be attracted by the 'noise', and remain alert for a few more slides on military hardware.

Communication as skill

Even in the simplest version of communication, which we have just been reconsidering, it is clear that successful communication requires the active participation of both sender and receiver. The artist or designer strives to convey a message in such a way that the audience can focus on it, interpret it, understand it and possibly act on it. The more effective the sender is in that role, then the easier is the task of the receiver. Both are equally involved in the success or failure of the exercise: telling is not communicating.

When the exercise does fail the blame can rarely be allocated to one party alone, although where the receiver is uninterested or uncommitted the sender must work a little harder to produce a convincing and persuasive message. This is particularly true of advertising: where a receiver is clearly aware of the persuasive

Jargon is a specialized form of language used by a group with specialist shared knowledge and expertise – CB enthusiasts, doctors, footballers, Christian Scientists, etc. It consists of endowing everyday language with an unusual meaning ('eyeball' for 'direct visual contact', in CB jargon) or in the invention of new words which will be understood only by fellow-members of the group ('appendectomy' for 'removal of a small internal organ' in medical jargon). Its principal use is economy, since it removes the need for roundabout explanations of concepts which are familiar to members of the group.

intent of an exercise, eager participation is not to be expected. Some of the most highly skilled film makers are employed in the production of television advertisements precisely because of the difficulty of translating entertainment into the action of buying the product or service.

Communication as shared experience

Wilbur Schramm's model explores further the issue of equal participation by sender and receiver and suggests that the successful communicator will correctly identify those areas of common interest shared by both parties and use these areas as a means of carrying the message. One of the important skills of the communicator is to use signs which are capable of producing predictable effects in the receiver. Failure may consist of using a sign which produces negative effects and is therefore counterproductive. Reacting to an unfamiliar sign is for the brain rather like a foreigner hesitating with a letter in front of two post-boxes.

Berlo (1960) combines the insights of Schramm (1954) with those of Shannon and Weaver (1949) in order to demonstrate the complexity of the skills, attitudes, culture and knowledge required for effective communication. Initial agreement on particular stances to issues being discussed allows further issues to be debated. Politicians and other persuaders identify with their audience a number of issues on which they are likely to agree: 'We are all concerned about the welfare of our children', 'There is too much government interference in our lives'. They can then move on to more contentious areas – 'This encyclopaedia will help your children pass their exams', 'Businessmen should be free to make money any way they choose'. The assumption is that at least some of the audience will continue to agree on the basis of their initial apparent consensus.

In the world of fine art, it is possible that the accessibility of Pop Art is due to the shared experience of the imagery used before its restructuring. The familiarity of the soup label or screen idol may be the equivalent of the shared values which initiate the involvement of the viewer with the total image.

Redundancy

Redundancy in communication is not something superfluous to the system, as it is in the world of economics, but a vital component which enables sender and receiver to overcome the limitations of the channel, their knowledge or their intelligence.

We make frequent use of redundancy in everyday, interpersonal communication. An obvious example is a situation where there is a great deal of auditory noise making the spoken word difficult to understand. A man asking a colleague who is working on a noisy grinding machine whether he would like something to drink will shout the words 'Do you want a cup of tea?' with elaborate movements of lips and tongue in shaping the words. He will often augment this with gestures aping the act of drinking tea, or forming the letter 'T' using his forefingers. The effectiveness of the communication is closely related to the redundant information.

In the world of advertising, much use is made of redundancy in enhancing simple messages because of the distractions available to the viewer. The clothes of the models in an advertisement for a car, and the scenery in which it is filmed, repeat an aspect of the message to be conveyed – 'This car is fast/luxurious/exciting/ cheap/hard-wearing' and so on.

Closure

Closure concerns the aptitude of the human brain to make sense of a confusing situation. Where the information available is incomplete – as in the obscured 'Parking' sign mentioned in Chapter 2 – the brain draws on previous experience to make up the rest of the picture.

Seeing is a thinking process. The brain in its search for meaning is constantly appraising visual stimuli, and seeking to fill gaps left by missing information. The mechanics of the cine camera, and the techniques of film editing, both depend upon our unconscious need to provide meaning for paradoxical information. The cine camera and projector both move the film in a series of rapid jerks, with the shutter opening and closing just in the fraction of a second when the film is at rest – eye and brain ignore the moments of darkness, and link the succession of fragmentary images through the illusion of continuous movement. The film editor splices together a sequence of shots knowing that the viewer will link them in the simplest explanation available – that they are all aspects of the same continuous action.

The visual illusions in Chapter 4 work precisely because of the extra information added by the brain on the basis of previous experience. A well tried technique in many areas of the visual arts and design is deliberately to present an incomplete image for the viewer to work at. Painters have long presented a portion of an image in the understanding that the experience of the viewer will be sufficient to supply the rest of the picture and thus elicit meaning from the picture.

In black and white photography and film, the exclusion of colour, a normal feature of 'reality' as we experience it, requires the

viewer to complete the picture. We have long been familiar with black and white photographs in newspapers, and are readily able to tease meaning out of such images. Black and white films provide less information for the viewer than is offered by colour. The need to add to what the image itself offers may paradoxically give the more restricted medium an attraction denied by colour, since it forces the receiver into a more active, involved role. This distinction is the basis of McLuhan's (1964) famous description of 'hot' and 'cool' media:

> A hot medium is one that extends one single sense in 'high definition'. High definition is the state of being well filled with data . . . Hot media are low in participation, and cool media are high in participation or completion by the audience.

McLuhan's point was to emphasize that film is a hotter medium than the novel or the folk-tale. It has been assumed that 'hotter' for McLuhan meant 'better', and that he was an enthusiast for the new, electronic media; the above quotation shows that his feelings were in fact rather more ambiguous. A medium which is 'high in participation by the audience' has more interesting, less authoritarian or manipulative implications than one which, through being 'well filled with data', imposes its views on the audience.

Many well known photographers of today eschew colour on the grounds that it makes the image too easy to comprehend, and thus diminishes its potential ability to stimulate new ways of seeing in the viewer.

Feedback

The earliest theories of communication saw feedback as an afterthought to the process: that it was possible to divide human interaction into actors and recipients whose effectiveness lay in responding to external initiatives. Osgood and Schramm (see p. 24) restored a balance: if there is a core to the interaction, it lies in the interpretation in which both parties are engaged all through the transaction. This is a dynamic process model, and can help to show why communication in the fullest sense must always be unpredictable, since none of the elements in it is stable.

More remote communication systems reduce the speed of interactions and therefore the potential for change; but even the authors of a book interpret actual or potential responses to their work at every stage. The publisher responds to initial outline ideas; a more detailed plan incorporates some of those suggestions, and also second thoughts provoked by them. Draft chapters are passed to friends, colleagues and students; a version

is then assembled for detailed comment by the publisher's readers before the final version can be printed. Advertisers try out ideas on clients and on panels made up of members of the potential audience. The most private of painters approaches a fresh canvas in a state of mind partially influenced by the reaction to previous work.

Denotation and connotation

Our habit of labelling things helps us to identify them, to communicate more easily, and to assimilate new events into our experience. When Rauschenberg combined a painting, a stuffed goat and a car tyre in a single composition, the search was on for a new label – mixed media seems to have won the day. When Duchamp exhibited his celebrated bicycle wheel, the initial confusion was partially resolved by coining the term 'readymade'. The question 'What is it?' when applied to innovatory art is usually a quest for a denotation – a label, or possibly a pigeon-hole. We may begin to understand something when we have denoted it: it then becomes amenable to critical appraisal. Where does it fit in the evolution of this particular category of art? Is it really innovative? Is it 'better' than its predecessors? What were the reasons for making it this way? – and so on.

Connotation, by contrast, is more subjective, and resists the pigeon-holing process. If labelling is the beginning of understanding then the triggering of personal associations and memories by a new work may be the beginning of appreciating and enjoying art. It is a truism to say that the more art you work at, the more you enjoy it. What is happening in perceptual terms is that the brain is riffling through the stored information about the medium or the subject-matter, and making comparisons with the painting being observed. This is a pleasurable human experience, and is even more so when the store of references is extensive.

Connotations work in both directions – from direct experience of reality to the vicarious representation of art, and in the opposite direction. Say 'Water lilies' or 'Haystacks' to a lover of Monet's work and you may observe a rapturous look appear on his face. A farmer or a canal cleaner might remember hard physical work, and produce a less uplifting response.

9 Designing for Communication

The principal aim of this book has been to offer insights which will enable artists and designers to make more effective use of their visual skills. However theoretical it has been necessary to make some sections, we have included nothing which cannot have a practical bearing on some aspect of visual presentation. Where necessary, we have provided actual applications of the concepts which we are passing on, but it has clearly not been possible to do more than offer a sample of the ways in which they can be used.

The reading lists and practical exercises at the end of chapters suggest one way to develop the theories which we have introduced; perhaps even more important is to apply the concepts to practical tasks and observations, to refine and improve the theory on which you base your analyses and descriptions.

In this section, we shall offer no new concepts or insights, but summarize what has gone before in the form of a check-list of questions which you should ask yourself as you handle a project.

What is your real message?

Your client may well have a clear idea of the purpose for which you are being employed, and may offer you a clear brief. However, many clients will be unaware of what you can add to a product, document or display, and may fail to tell you about other aspects of their plans which you could incorporate in your designs.

A secondary problem is the client who is unclear about the actual aim of a presentation: advertisements which are to increase the sales of a new product will be designed differently from those which aim rather to maintain a household brand-name in the public eye.

The solution to this problem is that the designer should be included in as many of the planning meetings as possible; if this is not possible, then the brief should include background information and reasons for defining the task in a particular way so that the contribution of the designer can be to strengthen the message rather than, weakly, aim to detract as little as possible from the message.

Even when you are not working to a commission, then certain aims will become apparent to you as you work. If your purpose is purely expressive, then you need to go no further; but if you are in some sense seeking to produce an effect (information, understanding, sympathy or awareness) then it would be appropriate to pause and analyse this before considering your work finished.

Who are you talking to?

A leaflet promoting a product which will be used by children may have two readerships – the children and their parents. You must know whether you are to reach one or both of these audiences. (The overt audience may be the children, but this may be a convenient fiction to encourage the adults to decide.) The whole design – colour, layout, illustrations and text – will need to be adapted to match this decision.

The more you know about the characteristics of your audience, the more effectively can you tailor your design. What limitations can we assume on their sensitivity to the codes we wish to use? Will they pick up any quotations you use? (If not, does it matter? If not again, why are you using the quotation?) Do they share your connotations for the signs which you are using? What are their needs?

What will make them look?

If you fail to attract the attention of your audience, the rest of your work will be wasted. However, this is not a licence to use any gimmick which your fertile imagination can produce: the first glance will establish a mental set, an expectation, towards the rest of your presentation which will be difficult to shake off at a later stage. A happy-go-lucky, whacky or weird gimmick will establish firmly that what you are offering is eccentric – and possibly unreliable.

Will their imagination do the work for me?

If you spell out your message in elaborate detail, then they may remember and believe it; or again, they may not. However, you will often establish a more memorable image by leaving the audience to fill in the blanks, and if their imagination has done this job for you,

the memorability and persuasiveness of what they see will be stronger.

The imagination is fed by icons (heavily used signs, rich in connotations) and symbols (signs whose meaning lies buried in the subconscious): both types of sign can be used to help lead your audience's mind in the direction you need. The semantic differential will check the former; only intuitive sensitivity and possibly psychological knowledge can predict the latter.

Have I used their prejudices?

If you aim to change one attitude in your audience, then you need to have a fairly accurate picture of other attitudes and needs which they share. A group of salesman who are to be persuaded to send their returns and travel-claims to head office promptly at the end of the month may be assumed to feel irritation at desk-bound administrators and to need reassurance that their skills and efforts are appreciated; a presentation which expresses these feelings has a greater chance of success than one which simply lectures at the audience.

Am I using the right medium?

Print, tape-slide, overhead projectors and video differ not only in their cost and the time which production can take, but in their suitability for different types of message. Video is unbeatable for personal and emotive appeals; complex statistics, which need time and thought for the receiver to absorb, should normally be conveyed by print and diagrams. Visuals to accompany a talk may be better on an overhead projector, where the speaker can refer to them or mask parts of them, than on other forms of projection which require blackout and thereby exclude the emphasis which the speaker's gestures can provide.

Any pictorial medium which you choose – photographs, oil, cartoons, line-drawing, pastel – has tasks to which it is best suited. A photograph may, for example, convey a stronger sense of immediacy than a watercolour wild-life illustration, but it is unlikely to include all the significant aspects of the creature it portrays; in this situation, a series of photographs are likely to be used as the basis for a painter's work so that a single image can be devised using the relevant parts of each. The connotations of each medium are also an important consideration.

Is the balance right between words and images?

It may not after all, be true that 'every picture is worth a thousand words'. Indeed, it sometimes seems as if one could turn that old adage around and say that every caption is worth a thousand pictures. As Barthes said:

> The photograph clearly only signifies because of the existence of a store of stereotyped attitudes which form ready-made elements of signification. (Barthes, 1977)

A picture is, on its own, ambiguous; its meaning derives from the context which it is given. This context is often supplied by the words which accompany it – title, caption or commentary. However, the combination of strong images with simple captions can be devastating. As a general rule, start with the images and layout and leave the text until later. The visual image is much more memorable than the unsupported spoken word; an emotional appeal, likewise, is easier when addressed to the eye.

Display and exhibition work is best considered as graphic and pictorial: captions need to be clear and brief.

Writing scripts for audio-visual and video presentations is a highly skilled operation. The commonest fault is to fill the soundtrack with words which the pictures have already made redundant; there is also a great deal of skill in suiting the flow of the text to the transitions from one image to the next.

Does my presentation mean what I think it does?

The message may be clear to you when you look over your presentation, but the longer you have worked on it, the less likely you can see it as a newcomer would. Furthermore, you may have assumed awareness of information, codes and quotations which your audience simply does not possess.

The greatest risk is with implicit messages – those which rely on closure, the bringing together of elements which the presentation leaves apart, or those which depend upon the addition of extra information not included in the message. Implications may be obvious to the sender but invisible to the viewer.

Under what circumstances will they see this?

Each situation has distinctive patterns of noise which can to some extent be anticipated. Often this noise is produced within the

channel that you are using, and furthermore time and place can transform the effect of a message. A television advertisement for fast sports cars which follows a programme about the rise in road deaths will have different effects from when it is shown during a film about *grand prix* racing.

A poster which will be displayed alone has far fewer design constraints than one which will be pasted onto a layer of others: its layout and colour will need to be bolder and simpler, for example.

Carelessness in the execution of a design may also be an internal source of confusion: anything which distracts from the effect which you intended should be altered.

If you anticipate a high level of physical, external noise, or problems caused by the complexity of the message, then you need to use a medium and approach into which you can build an equivalently high level of redundancy, of disguised or structured repetition.

The first impact of a message will decide whether and how the receiver continues to attend to it. You need to anticipate this labelling and selection.

Do you guide the viewer?

Any message except the very simplest consists of elements which the receiver needs to absorb in sequence, and whose relationship needs to be clear. Layout, captions and copy, colour – all means should be used to reinforce the cohesive structure of the whole. Isolated fragments are quickly forgotten; if they fit into a previously established structure, they become much more easily remembered. At every point, the receiver needs to know why this fact or idea has been included, why it is important, and how it is connected to the other parts of the presentation.

Finally, remember that the viewer must see immediately that your presentation fulfils a need or offers some pleasure or satisfaction. The initial impact needs to establish a frame of reference in which a claim of this type is made implicitly and credibly.

Bibliography

Barthes, R. 1973: *Mythologies,* Paladin

Barthes, R. 1984: *Image Music Text,* Fontana

Berger, J. 1972: *Ways of Seeing,* BBC/Penguin

Berlo, D.K. 1960: *The Process of Communication,* Holt, Rinehart & Winston

Britton, J. 1970: *Language and Learning,* Penguin

Carmichaiel, L., Hogan, H.P. and Walter, A.A. 1932: An Experimental Study of the Effect of Language on the Reproduction of Visually Perceived Forms, *Journal of Experimental Psychology,* 15, 73–86

Dyer, G. 1982: *Advertising as Communication,* Methuen

Eco, U. 1977: *A Theory of Semiotics,* Macmillan

Escher, M.C. and Locher, J.L. 1972: *The World of M.C. Escher,* Abrams

Fiske, J. 1982: *Introduction to Communication Studies,* Methuen

Fiske, J. and Hartley, J. 1978: *Reading Television,* Methuen

Gombrich, E. 1977: *Art and Illusion: a Study in the Psychology of Pictorial Representation,* Phaidon

Greenfield, P.M. 1984: *Mind and Media, the Effects of Television, Computers and Video Games,* Fontana

Gregory, R.L. 1971: *The Intelligent Eye,* Weidenfeld & Nicolson

Gregory, R.L. 1977: *Eye and Brain: the Psychology of Seeing,* Weidenfeld & Nicolson

Gurevitch, M., Bennett, T., Curran, J. and Woolacott, J. 1982: *Culture, Society and the Media,* Methuen

Hughes, Ted 1970: Myth in Education. *Children's Literature in Education,* 1

Jakobson, R. 1960: Linguistics and Poetics. In Sebeok, T.A. (ed.), *Style and Language,* MIT Press

Jung, C.G. (ed.) 1978: *Man and his Symbols,* Pan

Lasswell, H.D. 1948: The Structure and Function of Communication in Society. In Bryson, (ed.), *The Communication of Ideas,* Harper & Brs.

Leeper R. 1935: A Study of a Neglected Portion of the Field of Learning – the Development of Sensory Organization, *Journal of Genetic Psychology,* 46, 41–75

Lurie, A. 1982: *The Language of Clothes,* Heinemann

McLuhan, M. 1964: *Understanding Media,* Routledge & Kegan Paul

MacQuail, D. (ed.) 1972: *Sociology of Mass Communications,* Penguin

MacQuail, D. and Windahl, S. 1982: *Communication Models for the Study of Mass Communications,* Longman

Maslow, A.H. 1970: *Motivation and Personality,* Harper & Row

Mortensen, C.D. 1972: *Communication, the Study of Human Interaction,* McGraw-Hill

Osgood, C.E. *et al.* 1961: The Logic of Semantic Differentiation. In Saporta, S. (ed.), *Psycholinguistics,* Holt, Rinehart & Winston

Richards, I.A. (with Ogden, C.K.) 1923: *The Meaning of Meaning,* Routledge & Kegan Paul

Schramm, W. (ed.) 1954: *The Process and Effects of Mass Communication,* University of Illinois Press

Shannon, C.E. and Weaver, W. 1949: *Mathematical Theory of Communication,* University of Illinois Press.

Index

Index to plates

General index